DATE DUE

The End of the History of Art?

■ *Hans Belting*

The End of the History of Art?

Translated by Christopher S. Wood

The University of Chicago Press | Chicago and London

HANS BELTING is professor of the history of art at the University of Munich.

THE UNIVERSITY OF CHICAGO PRESS, CHICAGO 60637
THE UNIVERSITY OF CHICAGO PRESS, LTD., LONDON

Originally published by Deutscher Kunstverlag, Munich, 1983.
The present edition is revised and translated from the second
edition, Deutscher Kunstverlag, Munich, 1984.

LIBRARY OF CONGRESS CATALOGING-IN-PUBLICATION DATA

Belting, Hans.
 The end of the history of art?

 Rev. translation of: Das Ende der Kunstgeschichte?
2nd ed.
 Bibliography: p.
 1. Art—Historiography. 2. Art criticism—
Historiography. I. Title.
N380.B4413 1987 707'.2 86-24937
ISBN 0-226-04217-0

■ Contents

Preface

W E HAVE HEARD BEFORE OF THE END OF THE HISTORY OF ART: THE END BOTH OF ART ITSELF AND OF THE SCHOLARLY study of art. Yet every time that apparently inevitable end was lamented, things nevertheless carried on, and usually in an entirely new direction. Art is produced today in undiminished volume; the academic discipline, too, survives, although with less vitality and more self-doubt than ever. What does stand seriously in question is that conception of a universal and unified "history of art" which has so long served, in different ways, both artist and art historian. Artists today often decline to participate in an ongoing *history* of art at all. In so doing they detach themselves from a tradition of thought which was after all initiated *by* an artist, Giorgio Vasari, and in many ways *for* artists, a tradition which provided artists with a common program. Art historians appeared on the scene only much later. Today they either accept a model of history which they did not themselves devise, or shun the task of establishing a new model because they cannot. Both the artist and the art historian have lost faith in a rational, teleological process of artistic history, a process to be carried out by the one and described by the other.

The perplexity arising from this situation is not necessarily to be regretted, for it can incite the artist toward new objectives and the art historian toward new questions. What seemed for so long self-evident—the commitment to the concept of an all-embracing, universal "history" of art—suddenly strikes us as peculiar. But to reflect on the demise of a history of art is surely not to prophesy the end of the discipline of art history. Our theme is rather the emancipation from received models of the historical presentation of art, an emancipation often achieved in practice but seldom reflected upon. These models were for the most part varieties of stylistic history. They presented art

as an autonomous system, to be evaluated by internal criteria. Human beings appeared in these histories only as artists or, if need be, as patrons.

The old art history sustained its first crisis at the hands of the avant-garde, which declared itself hostile to tradition and erected its own historical model. Afterwards two versions of the history of art coexisted, models which in their notions of "progress" superficially resembled one another, but which in their actual accounts remained quite independent. Both versions preserved a faith in the existence of "art." But that art no longer presented a single face: it had to be defined separately for the modern and premodern periods. Thus the historical account broke down precisely at that point where it might have engendered an alliance. This failure only revealed the extent to which both versions of the development of art had survived on the self-understanding of artists and on the arguments of critics—even as the academic discipline was desperately seeking scientific methods of its own.

The resulting confusion can generate productive energies only if its sources can be understood. For we have arrived at a point where questions about the meaning and function of art can only be discussed profitably within a larger context of past and present experience of art. Today artists include both older and modern art in the same retrospective survey, accepting both as historical phenomena, as a single problematic legacy to be confronted or consciously rejected. Likewise, the boundaries between art and the culture and people that produced it are being challenged. The interpretative tools of the old art history were refined to such an extreme that they threatened to become ends in themselves, and in those fields where the inventory of historical material was more or less complete, they came to be of no practical use at all. Crossing the boundaries between art and its social or cultural "background" demands different tools and different goals of interpreta-

tion. Only an attitude of experimentation promises new answers. The connoisseur, although he retains his right to existence, can as little provide these answers as the positivist who trusts only in strictly factual information, or the specialist who jealously defends his field against dilettantes.

Today the artist joins the historian in rethinking the function of art and challenging its traditional claim to aesthetic autonomy. The dutiful artist used to study masterpieces in the Louvre; today he confronts the entire history of mankind in the British Museum, acknowledging the historicity of past cultures and in the process becoming aware of his own historicity. Anthropological interests prevail over exclusively aesthetic interests. The old antagonism between art and life has been defused, precisely because art has lost its secure frontiers against other media, visual and linguistic, and is instead understood as one of various systems of explaining and representing the world. All this opens up new possibilities but also new problems for a discipline which has always had to legitimize the isolation of its object—art—from other domains of knowledge and interpretation.

This is not to suggest that art historians are to abandon the work of art as their primary object of inquiry, nor are they to borrow from social history or other disciplines what they ought to find out for themselves. Both the role of art in human society and the nature of the individual work of art—its status as an image or its "figurality"—are permanently changing: they are more than ever deserving of scholarly attention. The role of art in our own society, at least in its traditional manifestations, is as uncertain as its further course is unpredictable. We no longer march forward along the narrow path of a unidirectional history of art, but instead have been granted a kind of momentary respite, in order to reexamine the various statuses and justifications of art, both in past centuries and in the era of

modernism. Artists today are rethinking their own tasks, the surviving possibilities of such media as painting and sculpture, in light of the historical legacy of art. Art historians are testing different models of telling the history of art, not the history of an unchallenged evolution but the history of ever new solutions for the ever new problem of what makes an "image" and what makes it a convincing vision of "truth" at a given moment. Finally, the problem of the status of modern over against contemporary art demands the general attention of the discipline—whether one believes in postmodernism or not.

The present situations of art history as a discipline and of the experience of art as a general phenomenon allow for no easy answers. Initiating a fresh discussion of problems common to all art historians seems more urgent than offering a program of action. Indeed, I am avoiding nothing so much as a new or other "system" of art history. On the contrary, I am convinced that today only provisional or even fragmentary assertions are possible. Moreover, I often judge from within a German background, which may seem a disadvantage for English readers but may also confirm that even in a world of disappearing boundaries, individual positions are still rooted in and limited by particular cultural traditions. This applies even more to personal convictions about art itself, which, however, are not my topic here.

The following essay is above all an assessment of the discipline as it is practiced today, and more particularly, an inquiry into its old and new problems in light of our contemporary experience of art. The second essay provides what the first lacks, namely, a retrospective on the earlier tradition of art-historical writing. Since they were first published the argument has been extended and modified somewhat in a shorter article focusing on the fiction of a world history of art and on further problems suggested by the contemporary art scene.[1] Meanwhile, the synopsis of

premodern and modern art called for in the following pages has been attempted in a monograph on Max Beckmann.[2]

The English version incorporates a number of revisions, clarifications, and altogether new observations, mainly in the sections of the first essay on modern and contemporary art (where circumstances change so rapidly). I am still fully aware of the limits of my capacity to deal with problems of this range. Whatever is new and more coherent in the English version owes much to the discussions with my translator and former student Christopher Wood (Harvard University), whose share goes beyond the mere labor of bringing my text into readable English.

■ One

The End of the History of Art?
Reflections on Contemporary Art
and Contemporary Art History

1. The Disengagement of Art from the History of Art

THE WORD "KUNSTGESCHICHTE" IN CONTEMPORARY GERMAN USAGE IS AMBIGUOUS. IT DENOTES ON THE ONE HAND THE history of art as such, and on the other the scholarly study of that history. Thus "das Ende der Kunstgeschichte," or "the end of the history of art," seems to suggest either that art is at an end or that the academic discipline is at an end. Neither shall be claimed here. The title is meant to raise instead two further possibilities, namely, that contemporary art indeed manifests an awareness of a history of art but no longer carries it forward; and that the academic discipline of art history no longer disposes of a compelling model of historical treatment. Such problems common to both contemporary art and contemporary art scholarship will be the theme of this essay. I would like to begin with an anecdote.

■

On 15 February 1979, the Petite Salle at the Centre Pompidou in Paris was filled "with the regular ticking of an alarm clock attached to microphones." The painter Hervé Fischer, who described these proceedings himself, measured the breadth of the room with a ten-meter tape.[1]

> Fischer walks slowly before the audience, from left to right. He is dressed in green, with a white Indian shirt embroidered with flowers. He guides himself with one hand along a white cord suspended at the height of his eyes. With the other hand he holds a microphone which he speaks into as he walks: "The history of art is of mythic origin. Magique. Ieux. Age. Anse. Isme. Isme. Isme. Isme. Isme. Neoisme. Ique. Han. Ion. Hic. Pop. Hop. Kitsch. Asthme. Isme. Art. Hic. Tic. Tac. Tic."
> One step before the middle of the cord he stops and says: "I, a simple artist, last-born of this asthmatic chronology, affirm and declare on this day

in the year 1979 that THE HISTORY OF ART IS ENDED." He takes one step further, cuts the cord, and says: "The moment when I cut that cord was the last event in the history of art." Letting the other half of the cord fall to the ground, he adds: "The linear prolongation of this fallen line was merely an idle illusion of thought."

He then drops the first half of the cord: "Free from now on of the geometrical illusion, attentive to the energies of the present, we enter the era of events, of posthistorical art, META-ART."

Hervé Fischer explains this symbolic act in his temperamental book *L'Histoire de l'art est terminée*. The new for its own sake "is already dead in advance. It falls back into the myth of the Future." The "perspectival vanishing point on the imaginary horizon of history is reached." The logic of a linear development, a development forward into a still unwritten and unrealized history of art, has been exhausted. "The ideal of novelty must be relinquished if artistic activity is to be kept alive. Art is not dead. What is finished is its history as a progress toward the new."[2]

Thus Fischer denounces the cliché of an avant-gardist history of art, and indeed rejects the entire nineteenth-century conception of history which could (for the bourgeoisie) celebrate progress and simultaneously (for the Marxists) demand it. Fischer is just a single voice in the chorus of the post-avant-garde, attacking not the modern as such but rather those modernist ideologies whose erosion has provoked the most widespread irritation. Whether written by historians, critics, or artists, the history of modern art as a history of the avant-garde, in which one momentous technical and artistic innovation follows close upon another, simply cannot be written any further. But the example of Hervé Fischer suggests also this: that the question of whether art has a history at all, and if so, what it might look like, is hardly a purely academic question, for historians and philosophers, but ought equally to concern

The End of the History of Art?

critics and artists. For the producers of art have always assumed that they were producing art *history* as well.

There is nothing new in this correlation drawn between the scholarly practice of art history and the contemporary experience of art. But not every art historian is willing to acknowledge it. Some practitioners consider the traditional conception of art indisputable and thus avoid questions about the meaning or methods of their scholarly work; their experience of art is limited to historical works and to private encounters with contemporary art, beyond their scholarly activity. For others, the task of theoretically justifying the study of art history is left to a handful of responsible authorities, and in any case is rendered superfluous by the success of scholarly practice. They answer, meanwhile, to a public more involved in art than ever, a public demanding that the discipline reconsider its object, namely, art.

Recent theoretical work, too, should encourage us to reflection. The recent anthology *Theorien der Kunst* edited by Dieter Henrich and Wolfgang Iser suggests that there no longer exists an integrative aesthetic theory.[3] Instead a multiplicity of specialized theories compete against one another, shattering the work of art into discrete aspects, disputing over the functions of art, treating even aesthetic experience itself as a problem. Some of these theories correspond to contemporary forms of art which, to quote Henrich, have "relieved the work of art of its traditional symbolic status" and "reassociated it with societal functions." With this we arrive at the main theme.

2. The History of Art as a Representation of Art

The enterprise which Hervé Fischer declared ended began with the conception of art history articulated by Giorgio Vasari in his *Lives of the Artists* of 1550.[4] In the introduction to the second part of that work Vasari announced ambitiously that he did not wish merely to list artists and

their works but rather to "explain" for the reader the course of events. Because history was "the mirror of human life," the intentions and actions of men were indeed its proper subject. Thus Vasari would strive to distinguish in the artistic legacy "the better from the good and the best from the better," and above all "to clarify the causes and sources of each style as well as the rise and fall of the arts."

Ever since these enviably self-confident sentences were written, the study of the artistic past has been dominated by the historical mode of presentation. Obviously art, like any other human activity, has been subject to historical transformation. Nevertheless, the question of a history of art is particularly treacherous. There have always been skeptics who deny outright that one could ever trace the history of an abstraction such as "art," as well as pious worshipers of art who adduce the proverbially timeless beauty of the museum-bound masterpiece as evidence for the independence of art from history. The phrase "art history" yokes together two concepts which acquired their current meanings only in the nineteenth century. Art in the narrowest sense is a quality recognized in *works* of art; history, meanwhile, resides in historical events. A "history of art," then, transforms a notion of art nurtured in the works of art into the subject of a historical account, independent of and only reflected in the works. The historicization of art became in this way the general model for the study of art.[5] It was always predicated on the conception of an *ars una*, whose integrity and coherence were reflected in an integral and coherent art history. Under the axiom of *ars una* as championed by the Vienna School of art history from Alois Riegl to Karl Swoboda, even objects which served primarily nonaesthetic purposes could be explained as works of art. Interpretation in the context of a unified art history transmuted them into aesthetic objects, into works of art in the sense familiar since the Renaissance.

3. Vasari and Hegel: The Beginning and End of a Historiography of Art

A mutual relationship between models of historical presentation and conceptions of art itself was established long before the nineteenth century. Already the rhetoricians of antiquity constructed historical models which proved clearer than the narrative styles of conventional historiography. They found it worthwhile to contemplate the genesis or decadence of the good style in literature or the visual arts: it permitted them to erect a norm of style which in turn seemed to constitute the very meaning of art. Historical development was thus construed either as an approach toward that presupposed norm, and therefore as progress, or as a retreat from it, and therefore as retrogression. Under this model the work of art simply represents an intermediary stage, a way station along the route toward fulfillment of the norm. Even if complete in itself, a work of art always remains open-ended in the direction of that norm. It seems paradoxical that a norm, of all things, should disturb the static character of a work of art, yet it is precisely the possibility of future fulfillment of that norm which renders every result relative and inserts it in a historical process. Moreover, the concept of style serves to name the various phases of the process and fix them in a cycle. The interpreter himself is always aware of his own standpoint within this process. Thus the historical representation of art began as applied art theory; it persisted in this form, however, long after that theory had outlived its usefulness.

■

Renaissance historiography, too, erected a canon of values, and in particular a standard of ideal or classic beauty. The advance toward the fulfillment of the norm represents for

Vasari the historical progress of art toward a universal classicism, against which all other epochs are to be measured. Obviously, the principles of composition of Vasari's art history are inextricably bound up with his standards of value: for this particular ideal of progress is only conceived in a late phase of an artistic development, namely, the classic phase.

The framework of the conception of the classic for Vasari, as it was for all his contemporaries, was the familiar biological cycle of growth, maturity, and decay.[6] The repeatability of this cycle provided the formula of rebirth or renaissance. The simile drawn between an ancient and a modern cycle may have only been a fiction, but it did seem to furnish historical proof of the very existence of a norm, a norm which because it had already been once discovered could therefore be rediscovered. The classic, then, merely realizes an already established norm. In Vasari's own eyes, a future art history would never find it necessary to alter these norms, even if art itself, to its own discredit, should no longer fulfill them. As long as the norms were acknowledged, history could never contradict him. Thus Vasari was writing the history of a norm.

The rigid framework of this art history was as practical for Vasari as it was impractical for his successors; and yet he was in a sense confirmed by his most important heir, Winckelmann. Winckelmann described not the art of his own time but rather that of antiquity, in the form of an internal or stylistic history of the "rise and fall of Greek art."[7] To be sure, Winckelmann drew an analogy to the political history of the Greeks; nevertheless his history preserved the format of an organic and autonomous course of development. Winckelmann's neglect of contemporary art in favor of the art of a lost and distant past challenged the monopoly which Florentine classicism had claimed upon antique classicism. From a standpoint of disinterested detachment Winckelmann sought an understanding of the

"true antique," particularly, because he hoped it would be imitated in his own time, in the visual arts. For all that is new in Winckelmann, the biological model of a cycle culminating in a classic phase retains its importance. And as before, aesthetic criteria determine the format and logic of the art historical narrative. For Winckelmann, art history was still a sort of applied art criticism.[8]

Indeed, not until much later was the disengagement of art historiography from a system of aesthetic values achieved, and then only at great cost. Historians of art came to invoke either the models of conventional historical scholarship or aesthetic philosophies, which had for their part undertaken to define art outside a historical and empirical context. Here, to speak with Hans Robert Jauss, "historical and aesthetic points of view" part ways.[9] At the core of this most fundamental shift stands Hegel's philosophy of art. Hegel's aesthetics is on the one hand inextricable from his entire philosophical system: on the other hand, as reflections upon art and its status in the modern world, many of his ideas very much retain their currency and indeed their capacity to provoke further thought.[10]

For our purposes the "new" in Hegel's aesthetics consists in its philosophical justification of a historical treatment of the development of art, indeed the art of all times and of all peoples. "Art invites us to intellectual consideration, and that not for the purpose of creating art again, but for knowing philosophically what art is." The aim of art history, then, is to define the role of art, a role which has already been played out.[11] Crucial is the idea that art, as a projection of a Weltanschauung, is inextricable from the history of culture. Thus although modern interpreters may persist in considering art merely as "art," this art was not in fact heeding a norm inherent in its own nature, but rather was drawing on the historical circumstances and material at its disposal to express a Weltanschauung.[12]

The idea of a history of art as a history of the function of

art in human society has been subsequently disparaged as an "aesthetic of content." And yet, provided that it is severed from its dogmatic mooring in Hegel's "system," it remains very much pertinent. Hegel himself even sketched out, in part, a working historical model for the development of art. "It is the effect and the progress of art itself which, by bringing before our vision as an object its own indwelling material, at every step along this road makes its own contribution to freeing art from the content represented." When "the content is exhausted" and all the symbols bereft of their meaning, then "the absolute interest" is lost, and art, having fulfilled its special mission, is "rid of this content." Further artistic activity along this line proceeds only in contradiction to the content. However, in modern art the "bondage to a particular subject-matter and a mode of portrayal suitable for this material alone" is no longer obligatory, and indeed becomes "something past; art therefore has become a free instrument" which the artist uses for himself and with regard to "the substance of his own consciousness. It is therefore no help to him to adopt again, as that substance, so to say, past world-views," as for example when the Nazarenes converted to Catholicism in hopes of reviving art in its primal functions.[13] Precisely that which Hegel identifies as the universal essence of art—its symbolization in objective form of a historical Weltanschauung—must ultimately, and paradoxically, be a phenomenon of the past.

Hegel's aesthetic philosophy is perhaps best introduced to our argument in the problems of the "classic" style and of the "pastness" of art. We are forced here to simplify drastically. The classic phase of any art is its "moment of perfect development as art," in which it demonstrates what it is capable of as art.[14] This sounds familiar, but was in fact established by Hegel on quite new grounds. The idea of cyclical repetition within a particular art form— sculpture, for example, or music—is given up entirely. The

classic does not end in decay which can then be reversed, as in earlier theories: the classic is bound to a mental and cultural development which is not repeatable. Rather, the classic is "transcended" by romanticism, which for Hegel enters art with Christianity. The classic becomes in its new remoteness as inoperable as it is inviolable. Painting and music succeed sculpture as artistic forms of higher abstraction, forms demanded by the subject on its historical trajectory toward reconciliation of spirit and world. But the ultimate resolution of this fundamental disunity, which Hegel found to be preserved in all contemporary theories of art, will subsequently be delegated not to art but to philosophy. The novelty in these ideas is evident. It consists not in locating the classic phase in art, but rather in locating art in history, namely, as a transitory stage in the process of the spirit's taking possession of world. Art, as a sensory manifestation of the spirit, has assumed a historical function. Thus art can—indeed must—become the subject of a universal art history, through which this function can be reconstructed. Here, too, if in a different way from that of Hervé Fischer, is implied an end of the history of art.

But this "pastness" of art, its "death within the historical world" (as formulated by a dissenting Benedetto Croce),[15] serves Hegel's argument in a way too complex to be reduced to the thesis of an "end of art." "Art, considered in its highest vocation, is and remains for us a thing of the past. . . . [Art] has rather been transferred into our *ideas* instead of maintaining its earlier necessity in reality and occupying the higher place."[16] Where an absolute necessity is lacking, "art, taken purely as art, becomes to a certain extent something superfluous."[17] Art may well develop further, but its form has "ceased to be the supreme need of the spirit."[18] None of these thoughts can be extracted from the argument as a whole. The "pastness" of art cannot be discussed outside the "system." Likewise the concept can-

not simply be applied to the contemporary crisis of art as dramatized by Fischer, as if this had all been anticipated by Hegel.[19] Rather, Hegel's argument was symptomatic of a new understanding of art itself characteristic of his epoch. On the basis of this understanding rests the entire project of the historical study of art as a scholarly discipline.

Art is something "past" not only because it was created in another time in history but also because it fulfilled another function in history, precisely that function from which, in Hegel's view, it had achieved aesthetic emancipation in his time. As Joachim Ritter formulated it, "older art, when treated historically, deserts both the context of its historical world" and its historical function.[20] Its "resuscitation" corresponds to contemporary culture and its capacity to "appreciate" historical works of art.[21] "The pastness of art in its highest sense implies that the work of art—once endowed with an aesthetic presence—no longer stands in that religious and historical context out of which it emerged. It becomes an autonomous and absolute work of art."[22] Thus reflection on art gains a new dimension. But at the same time it cuts itself adrift from contemporary art. Hegel offered art history as contemplation of past modes of human expression, modes which no longer—as with Winckelmann—suggest a model for the future of art itself.

4. Art Historians and the Avant-garde

Hegel and the art historians of his time stood at a turning point in the history of art scholarship. After the romantics invoked historical art for the last time as an example for contemporary art, the art historians and the artists parted ways. The historians, with notable exceptions such as Ruskin,[23] no longer found room for the artists of their time in the tradition of art, and indeed usually ceased to write an unbroken history of art into the present. Artists no longer turned automatically to masterpieces of historical art for guidance but rather subscribed to a new "mythology," the

The End of the History of Art?

self-appointed mission of the avant-garde.[24] History under this metaphor becomes an army with the artists playing the role of a sort of band of advance scouts. The forward march of art becomes the responsibility of a cultural elite who feel entitled to define progress among themselves and who are nonetheless convinced that history will take up the rear. It is an elite of progressives, replacing the earlier elites of power or high culture but paying for this privilege with the stigma of the outsider.

It is significant that the term "avant-garde," once it had been introduced by Saint-Simon, oscillated constantly between political and artistic applications. In the political domain it was the label of the utopians and later the oppositionists, in short, any faction whose social visions could not be realized.[25] In the artistic world it was the emblem of the *Refusés*, who broke with the Salons and the conventions of official art. In earlier dreams of unity, political and aesthetic avant-gardes were programmatically intertwined. In practice conflict broke out between these two utopias, between artistic autonomy and political anarchy, as the history of the debate over autonomous or engaged art demonstrates.

■

Since the development in the nineteenth century of an empirical art scholarship, then, art criticism and art history have been essentially separate enterprises. Only occasionally would contemporary art furnish points of contact between the two parties. Alois Riegl and Heinrich Wölfflin, to name two prominent examples, harmonize in a curious way with tendencies of the fin de siècle. In their hands historical art seems to take on traits of contemporary art. Riegl's notion of "style," for example, was abstracted from all other factors which condition a work. Its "leveling potential" was so great that out of the historical works could be distilled an abstract notion of an *"art pur."*[26] Wölff-

lin's "principles," which were supposed to correspond to "forms of seeing," appeared simultaneously with the first abstract paintings. And yet this is a quite different situation from before. Art history was no longer practiced with a *view* to, but rather under the *impression* of, the contemporary art experience, and not necessarily consciously.

For it is worth making the distinction between the art historian (like Ruskin) who wrote about the history of art in order to propose lessons for the art of his own day, and the art historian (like Riegl, Wölfflin, or Franz Wickhoff) who was merely unable to avoid seeing historical art with eyes trained from recent art experience.[27] Usually, as for Wickhoff and later on for Werner Weisbach,[28] it was not modern art but traditional art which was the "victim" of an altered aesthetic conviction. Traditional art suddenly seemed to offer what one had come to know—or else to miss—in modern art. Most such authors wrote without ever feeling challenged to rethink their evolutionary models or to reflect on the historical rupture that modernism implied. In rare cases, such as Wilhelm Worringer's doctoral dissertation, "Abstraktion und Einfühlung" (Munich, 1907), the retrospective on historical art revealed such "modern" features in old art that even artists felt justified in their views: what had hitherto been mere archival material or museum pieces for the conservative bourgeoisie had finally been "correctly" interpreted. In short, points of contact between art production and art history were almost as many in kind as there were art historians. And yet fundamentally the two activities were carried out on different planes: the historical discipline did not normally define its task in light of what had happened to art in modernism, nor did it wonder whether these experiences might have any impact on their traditional humanist program.

Of course, there was confidence among all those who directly or indirectly sympathized with the creed of avant-

The End of the History of Art?

gardism that art follows a continuous path of progress and innovation. There was no need to fear the rejection of traditional by avant-garde art as long as the latter seemed merely to extend what the former had already initiated: the perpetual renewal of the physiognomy of art. Since avant-gardism was best judged by its formal innovation, the saga of stylistic evolution seemed to offer more or less a universal art-historiographical paradigm. Thus the obvious temptation was to write a continuous history of avant-garde art from the very beginning all the way to the present, and so to deny that the breaks which had occurred in any way threatened the imaginary continuity of eternal art. It is only with the crisis of avant-gardism and the loss of confidence in meaningful continuity and direction that this program of writing art history has been deprived of its most needed support from the contemporary experience of art.[29]

5. Contemporary Methods of Art History

Yet already in the nineteenth century art history had earned the task of arranging historical art in a meaningful sequence without being able to appeal to a stable conception of art. In this art itself offered no further guidance, and yet retained just enough autonomy to continue being studied as "art." Excepting such positions as Semper's materialism, the task was understood to be that of ordering the works of art in the "musée imaginaire" into a sequence which appeared to be governed by a lawful development of form, as for instance in Wölfflin's so-called "art history without names" or in Ludwig Coellen's *Der Stil in der Bildenden Kunst.*[30] The exclusive concentration on artistic form, as opposed to content or function, was seconded by traditional aesthetics, which had all along preserved a philosophical conception of "art." This was still, for example, the position of Adorno: the function of art is its lack of function.[31] Stylistic history in its purest form, accordingly, banished from its historical ex-

planation all those factors and conditions which were not originally artistic.

In the following pages I would like to sketch critically some of the historical approaches developed in the meantime, to challenge their respective claims to exclusivity, and to characterize some of the problems they have bequeathed to us. For although these approaches are as useful as ever in illuminating aspects of the work of art, they can no longer claim to represent all that art history is capable of; nor must they ever be confused with timeless rules of procedure.

■

Some particularly ambitious variants of stylistic history declared themselves to be the keys to general historical explanations. Riegl's "Kunstwollen" is the most famous and disputed attempt to identify an independent impetus behind the transformation of forms. The term was introduced, in the spirit of historicism, against the axiom of artistic skill, so that even an archaic or decadent style could be measured in terms of its own intentions—a logical consequence of the new science of art which made everything its object.[32] Because every "Kunstwollen" corresponds to a respective Weltanschauung, the latter too became a stylistic phenomenon. Artistic styles became the visual projections of styles of living or thinking. The history of forms, in a somewhat startling about-face, now teaches us general history: from the style of an age is extrapolated the entire spirit of an age. The art historian could explain "history" through the history of "art" and its all too clear pattern of change and development, and at the same time explain "art" by tracing its course and transformations in "history." This project asserted not only the autonomy of art, its timeless existence beyond its constantly changing faces, but also the autonomy of a discipline over against mere historical or social disciplines. Obviously this smooth symmetry be-

The End of the History of Art?

tween style and history fails to come to terms with all the immense difficulties involved in reading an outer meaning into the "inner history" of art. Riegl, and after him Max Dvořák, raised as well the intriguing possibility of a historical psychology of art. But it remained a possibility, never properly pursued by their followers. For apparently nothing could prevent the emergence of an independent stylistic history which purported to embrace hermeneutically the entirety of art.

The concept of a "Zeitstil" was even questioned by other factions from within the camp of stylistic history. I have in mind the self-generating "vie des formes" conceived by Henri Focillon and extended by George Kubler in his fascinating study *The Shape of Time.*[33] Here we encounter a remarkable revision of the old cyclical model. A particular artistic form or problem follows, under the most varying conditions, similar cycles, which do not fit into a chronological framework but rather obey an internal schedule: the successive phases of an early form, a mature form, and so forth. Thus the model of problem solving is brought to life again, although this time without the aesthetic doctrine indispensible to Vasari. The new sequences are not repeatable, because at a certain point in the sequence the problem changes and a new sequence is inaugurated, which then according to the particular evolutionary conditions at hand finds its own time curve. The date of a work is here less important than its "age" in a sequence of trials and errors. One sculpture can be contemporaneous with another and yet, according to theme or technique or purpose, stand at another point in the sequence: it could for example be an early form which shares a historical date with a late form. Chronological time, which groups simultaneities together under the rubric of a Zeitgeist, is here distinct from systematic time, that is, a time curve within a system, or as Adorno would put it, "under the unity of a problem."[34] It is not the objective chronological length of a

cycle which matters but rather its tempo, which may be governed by very different conditions. These ideas have long been familiar to natural scientists and anthropologists. But like all versions of stylistic history, Kubler's approach is overly rigorous when it singles out particular features or problems of historical art and then attempts to trace their courses through a morphological development. And whereas in Riegl's case the symmetry between style and history was reached too quickly, here the Zeitgeist never makes an appearance at all.

■

The history of art reduced to the development of forms could hardly live up to its claim to be a synthetic representation of historical reality. It was thus only logical that formal analysis found a pendant in iconology. The problem of the content of art was simply delegated to a different "method." This only institutionalized the idealistic divorce of form and content. It also implied the final divorce of art from history. Content was excluded from the analysis of forms, and forms from the analysis of content: at least as long as one understands forms as more than mere signs or codes for content. The objections to all this are obvious. Content often only materializes in its definition through artistic form, and may not even exist on its own at all. Likewise, artistic form is often the interpretation of a particular content, even if this content is nothing more than a certain notion of art. The divorce of content and form robs historical form of its true substance. Form is not the mere mirror of an internal evolution, nor is content—the reference to the world and reality—exterior to form.

The iconologist inquires after the original meanings of works of art and the cultural interpretations encoded in them. The process of decoding itself is celebrated as a hermeneutic act, symmetrically complementing the original, historical encoding.[35] Too often this degenerates into a

The End of the History of Art?

perpetuation of a humanist parlor game, an exercise only promising success in the cases of Renaissance and Baroque works of art, especially those with literary texts and programs created expressly for them. This certainly does not apply to the original version envisioned by Aby Warburg, which sought to locate art within a vast repertoire of forms of cultural expression, as one of an entire array of symbolic languages within world culture. But this approach was never developed further and was instead narrowed into a method for interrogating works of art from the age of humanism.[36]

Iconology in its narrowest and most dogmatic application was even less likely than stylistic criticism to construct the desired synthetic art history, not least because it could not identify a "real" object of that history. Iconology would have had to, against its will, lift the restrictions on the classical genres of "high art" and to broaden the field of questioning to other sorts of images and texts. Riegl, as we have seen, had already done precisely that. He deliberately transferred the conception of style developed for art onto all that which would later be called material culture, onto objects of fashion and everyday consumption.[37] His procedure corresponds in a remarkable way to the aestheticization of the living environment undertaken by Art Nouveau. But precisely this obsession with definitions and demarcations betrays in its own way just how difficult it was to make "art" the object of art history.

■

This applies as well to a strain of hermeneutical thought from which art historical scholarship has borrowed considerably and out of which certain specifically German idiosyncracies have developed, especially in terminology and the use of language. I must generalize here and at the same time limit myself to problems of the idealistic tradition—the so-called philosophical hermeneutics represented by

Dilthey, Heidegger, and Gadamer—which in their art-historical application became most virulent.[38] It will however be granted that hermeneutics "overcomes the positivistic naïveté which lies in the very concept of the 'given,' through reflection upon the conditions of understanding." In so doing it offers a critique of positivism, and as such is today no less pertinent.[39] Without this exercise in self-reflection scholarship loses its own direction. In this sense every self-reflective art history is grounded in a hermeneutic tradition.

The problems arise when the aesthetic experience—that is, an essentially prescholarly experience—is declared the object of scholarly inquiry. Such problems reach back into the ancestry of aesthetics and hermeneutics. Once an absolute aesthetic became no longer tenable, the theme of ideal beauty was replaced by the single work of art, which reconstituted itself afresh as the object of scholarly investigation. The end of the philosophical concept of "art" as such marks the beginning of the hermeneutic concept of the "work." The quarrel over judgments of taste and aesthetics is left to art criticism.[40] The objective for scholarship is no longer the vindication of an ideal of art but rather interpretation as a method. The interpreter, according to Dilthey, aims at a "scientifically verifiable truth"; he is able to "understand" the aesthetic product, namely, through a productive process of understanding between the subjective consciousness and the aesthetic constitution of the work.[41]

But the consciousness here becomes more important than its object, and the interpretation, which is bound to its own perception of things, in the end confirms only itself. In its less felicitous art-historical applications it permits the interpreter, left to his own devices, to "reproduce" the work in the conjuring act of a guaranteed method. The danger increases when such hermeneutic principles harden too quickly into a system. The "creative act of viewing"

The End of the History of Art?

(Sedlmayr) is exercised upon an object which is meta-phorically called a "Werk" and distinguished from a material "Kunstding."[42] Too often the interpreting art historian sets himself up as a second artist, a "re-creator" of the work. I would like to avoid this conception of a "work."

This application of hermeneutics—polemically characterized here—has left us suggestions for the analysis of works of art but no compelling model of art historiography. It has tolerated historical research only as a preparatory stage, an auxiliary discipline beyond which according to Sedlmayr the "second" art history actually begins. Today the terminology left behind by this school has become more of a hindrance than a help. A conceptual vocabulary, like the understanding which it represents, must remain open to change and revision. Here a questioning procedure became entrenched which ought to have been renewed for every generation. It is in fact a contradiction in itself when the interpretation of an aesthetic product is raised to a universal rule and fixed as dogma. Because understanding in Gadamer's sense is always a process of self-understanding for the interpreter, it could never produce a generally valid insight.[43]

■

A methodological problem of a different sort ensues when forms are referred back not to ideal types but rather to vision itself. It is perhaps best examined with reference to Wölfflin. The famous principles, such as "open" and "closed" form, constitute a catalog of general laws which are grounded on two fundamental premises: first, that art itself is circumscribed by certain a priori limits; second, that these limits correspond to equally limited possibilities of seeing, which exist as physiological and psychological constants.[44] I do not wish to challenge these theses so much as the use which Wölfflin made of them when he classified stylistic epochs with only a few, supposedly uni-

versal, criteria. The "natural laws" of art which Wölfflin recognized in the alternatives chosen by the great historical epochs for him became the true objective of scholarly analysis. He pretended that it was possible to produce a perfect symmetry of vision and structure, and of interpretation and art. But the problem is greater than these objections might suggest. Seeing is surely not merely derived from biological conditions, but rather reflects cultural conventions which, to put it briefly, are not to be explained by the physical structure of the eye. Since vision is in its turn subject to historical conditions, Wölfflin finds himself at a loss to explain its transformation.

The whole topic of historical vision and historical style, obviously, raises still larger issues in the realm of psychology. Already Wölfflin had ventured into a potentially fruitful psychology of forms but did not develop it for fear that it would interfere with his system of humanistic values and aesthetic norms. Yet the crucial problem for any history of forms remained the problem of finding a psychological key to artistic form, a key which would unlock the mystery of the metamorphosis of art. Granted, it is never just pure forms which we see but rather forms already teeming with life and meaning. Thus as soon as artistic form was understood as a mediated reality, the psychological implications of vision could become explosive.

Psychology, however, cannot investigate the cultural communication of reality with its own means, because then it would have to define first what that reality was.[45] The relationship between the content or subject of an image and its form lies beyond the range of psychology, because one must first know *what* is communicated in an image in order to show *how* it is communicated. The psychology of perception and representation, so brilliantly spoken for in Ernst Gombrich's work, locates the problem in the conventions and transformations of mimesis: the reproduction of nature in the artistic image, the translation

The End of the History of Art?

of vision into representation.[46] It succeeded in correcting the naïve model of an ever more perfect duplication of nature in art by revealing in our conception of nature *conventions*, whose matching and correcting generate stylistic change.

Gombrich in *Art and Illusion* uses such generally valid patterns of perception to explain what takes place in the work of art when it reproduces the world. His "psychology of stylistic change" describes the history of styles (like the histories of taste and fashion) as a history of options for or against possible forms which are then tested against the object (nature).[47] The history of art is thus construed as a learning process in which the representation of reality is posed as a permanent problem.

It would, however, be an error to reduce the entire problem of artistic form to an act of imitation. Imitation is only measurable where art imitates *nature*. But when art imitates *reality*—social, religious, personal—the constants against which the result of the imitation are to be measured fall away. For reality is always changing. It must always be defined anew before its transmission or imitation can be evaluated.[48] But then of course each humanistic discipline (social history, intellectual history, and so forth) will insist on defining historical reality in its own way. Thus the art historian finds himself confronted with a methodological controversy which should only prompt him to greater modesty in his own field.

6. Art and Reality

Granted, some theories of art deny that art has anything to do with reality at all. A familiar variant is the view of art as a beautiful illusion which disguises or fancifies reality. A utopian version offers art as an apparition of a possible future, or a promise of personal happiness. But even the positions that see art only as an illusory reality, or only as a projection of a reality, offer an agenda for historical re-

search: for they too interpret reality, directly or indirectly, positively or negatively. Reality materializes first in the mind of the individual who interprets it (in our case the artist), and then again in the mind of the individual who apprehends this interpretation and either accepts or rejects it (in our case the beholder). Artistic mimesis thus always articulates an experience of reality. This reference to reality obtains even in cases of extreme aesthetic camouflaging or encoding. It applies, in ways which were hardly foreseen, to twentieth-century art.[49] I am thinking of the mystical claims of so-called abstract art to make the invisible visible and to reveal natural laws hidden behind perceived surfaces. Both Max Beckmann when he spoke of transferring "the magic of reality . . . into painting" and Paul Klee when he said, "Art does not reproduce the visible, but makes visible," were referring art to reality.[50] Reality is never what it seems to be at first glance. Even the apparent antithesis to abstraction, hyperrealism, is itself just another strategy of perception, and as such not altogether different. For the reproduction of reality is not simply a matter of technical ability. Not even photography, the self-proclaimed medium of objective documentation, kept its promise: instead it became, in the hands and with the eyes of the photographer, a highly individual vehicle for the interpretation of reality. Virtually as many appreciations of photography could be cited as there are ways of seeing and representing the world.[51]

In the nineteenth century the artist went out into the open air in order to see nature differently from the way it had been handed down to him by a canon or a workshop tradition. But nature was not the only object: the artist began to analyze contemporary civilization, whose urban and industrial aspects struck him as the quintessence of "the modern." Modern life brought subjects and themes into play unknown to the old academic hierarchy of genres: technology, for example, or the metropolis.

The End of the History of Art?

But even naturalism and realism, in the original versions of Courbet and his generation, did not in the long run succeed in providing art—still at the margin of society—with meaning and functions. Every "reproduction" suffered from the sheer inadequacy of reality, or from the mutability of reality, with which it could not keep pace. The ever circulating styles were already compromised by their pluralism and inflation. So arose the desire both for an unspoiled reality as well as for a compelling "truth" in art, to be manifested in an authentic, timeless style. Programmatic intentions were often subject to the utopias which developed with the pure forms of an ideal art. The tension between art and life, artist and public, persisted as the artists retreated into private worlds created only for their own visions.

In the nineteenth century art found itself estranged from ordinary experience and perception and so sought new ways of seeing reality. Disencumbered of superficial reproductive tasks and discharged from conventional societal functions, art could formulate its own strategy of perception and cognition of the world. But these new ways were inevitably referred back to the old ways, to the banal, false, and culturally exhausted formulas for the reproduction and experience of reality. Naturalism acceded to the grand claims to objectivity of the natural sciences; symbolism on the other hand maintained its distance from those same claims. Finally, rejecting once and for all a static world view and the conquest of nature through linear perspective, art invented ways of seeing which were prelinguistic and no longer culturally determined.[52] The "réalités inconnues" (Monet) are always distinct from a known reality. Although such artists claimed access to a timeless reality, this reality too is ultimately only comprehensible historically. In this sense, Peter Gay, in his book *Art and Act*, reconstructed the historical contexts of Manet, Gropius, and Mondrian. New modes of perception

were tested, both as new approaches to reality, and as approaches to a new reality. The "nouveaux réalistes" sought to resolve the estrangement from mass culture which abstract painting had attained. Provocations and mental and perceptual games obliged the beholder to reflect on his own reality, and at the same time to acknowledge his own expectations from art. Art and life—either in mutual illumination or mutual denial—stood simultaneously at disposal. The history of this confrontation could be extended ad libitum. In our context it bears witness to the importance of speaking about reality whenever we speak about art. This relationship is immanent precisely in the form of the work of art, which either as image or counterimage always participates in a dialogue with a recognizable form of reality. It is supplemented by the diachronic relationship to other statements about reality which the artist encounters in the history of art, and which either correct or confirm him.

7. Art or Work of Art? Artistic Form as Historical Form

At this point in the argument we may agree that art does not merely exist within an internal history of forms exclusive to a particular genre or medium. Indeed, in such a state of isolation it is robbed of the full quota of reality with which it was endowed. Stylistic criticism is pitched at a high level of selection in its interrogation of the work of art, underrating both its claims and its binding force, indeed, selling it short. Art set free in this fashion, even to the idealistic extreme of being removed from the context of style, has always found its panegyrists. Art thus assessed is especially ill suited to a historical treatment. It can become the theme of philosophy but not of historical writing.

This thesis in no way denies the fundamental insight that artistic form survives as an object of contemplation even after the original message has lost its immediate force. For it is precisely this survival of form which con-

stitutes the experience of art in the familiar sense; indeed, the appeal, the fascination of form sets historical questions in motion in the first place. It manifests itself in the work as a creative power, not only to articulate reality but also to transcend it, thus letting the artistic answer to reality endure. Yet this is no excuse for not posing historical questions to the work of art.

The common denominator of the historiography of art had always been, above all, an ideal notion of art which was then explicated through the history of art. The loss of this paradigm did not eliminate the experience of art, but—just as did the loss of a traditional conception of history—it transformed scholarship.[53] The discipline won new insights into its material and had to account for these insights with new theories. Only the work of art itself—not a definition of art, whatever it might be—was capable of resisting the pressure of the new questions. This was of course always an object of interest, but now it was seen in an entirely new way. The work of art testifies not to art but to man. And man in his artistic appropriation of the world does not lose contact with the world but rather bears witness to it. He reveals his historicity in his limited world view and limited range of expression. In this sense the work of art is a historical document.

Thus it is understood by Svetlana Alpers when she poses the question "Is Art History?"[54] In this polemical formulation the work of art, instead of "art," is put to interrogation and as a "piece of history" restored to that historical territory from which it had been uprooted by the champions of an autonomous art. Autonomous art had been thought of as the bearer of a "higher truth." The mystery of the creative act itself, removed to a sort of aesthetic no-man's-land, only fostered this sort of idealism. Thus Alpers could plead for a "demystification" of the creative process.

Artistic form is a *historical* form: it was so often conditioned by genre, material, and technique, but also by con-

tents and functions, that it cannot be extracted from this web as "pure form." No longer can Wölfflin's "inner history" of art, in which "every form works creatively further," be read from form.[55] Recent concepts such as "iconographic style" or "genre style" correspond to a change in questioning strategies. The new concepts demonstrate that the old notion of a style traveling on a one-way street of formal development has collapsed.[56] In its place appears the work of art, which occupies the intersection of the general historical and individual lines of development. It is bound as much to a contemporary horizon of experience as to historical traditions.[57] Just as it was generated by more than other works of art, so it bears witness to more than just art. Countless conditions which entered into it, and effects which proceed from it, converge to a single point, as in a lens, in the work of art.

Several recent studies have tried to relate or coordinate the visual structure of works of art, their aesthetic organization, to more general notions of their time and culture. I only mention the works of Michael Baxandall, such as *Painting and Experience in Fifteenth-Century Italy*, or Alpers's own much discussed *Art of Describing*.[58] But there is still another approach to artistic form as a truly historical form. Now that the notion of style, be it the style of an era or the style of an artist, has lost its central status, there has emerged a new interest in what it is that makes an image an image, or to put it differently, how artists have conceived of the aesthetic constitution of their products. Pertinent examples are Michael Fried's *Absorption and Theatricality*, Wolfgang Kemp's *Der Anteil des Betrachters*, and Norman Bryson's *Word and Image*.[59] For the "figurality" or quality as an image of a painting, as distinct from a text, has had a history of its own which is still largely untold. In writing such a history we find ourselves alongside the artist, tracing the career of the concept of image he was using and sometimes inventing. For it was never just the mate-

The End of the History of Art?

rial work as such that he was producing but also a certain conception or definition of what this work was to be. This applies most obviously to the seventeenth century and thereafter when painting became at times its own subject matter, commenting upon itself as art, or as a demonstration of painterly skill, or on the nature of such skill. But the awareness of visual structure as a problem surely predates the moment when the artist was allowed to make it the topic of his creation. The historical change of artistic form, finally, was prepared by a concern both with meaning entering the work from an outside source and with the reproduction of visual truth and "life." If we conceive of form not only as a witness of style but also as a witness of an image of style, then we discover a new historical sequence which makes room for all the various individual concepts of a work.

8. Possible Areas of Art-Historical Research

The project of writing the history of art has survived all too often on the fiction of elevating artistic form to the single hero of the story. But there is no new model in sight which could claim the same comprehensiveness. For the more complex our conception of the work of art and its manifold determinants, the more difficult becomes a synthetic treatment, a narrative still capable of bringing art into the unified perspective of a "history of world art."[60] Traditional art history, which had achieved precisely this, can serve today only as a foil before which new tasks for empirical research may stand out in relief. Some of these I would like to mention in passing, with no intention of setting out any sort of "program" for future research.

1. The dialogue among the humanistic disciplines is becoming increasingly more important than the independence of the individual disciplines. Theoretical statements from within fields, which especially the younger disciplines have cultivated in hopes of demonstrating their sci-

entific rigor, tend toward closed systems and only hinder this development. Openness to other disciplines is surely to be encouraged, even at the price of professional autonomy.

2. Stylistic history cannot simply be replaced by social history or any other simple explanatory model, though there have been several promising attempts to enlarge traditional models of sociological research in this area.[61] Any approach which neglects the form of the work of art, indeed, fails to make it a central theme of the analysis, is dubious at best. For with this form the work expresses what it has to say. Form is not so easily deciphered as it might at first seem. Nevertheless, functional analysis and reception aesthetics offer the possibility of relating the specific qualities of a given work of art back to the world to which it referred.

3. Reception aesthetics as developed for literary history by Hans Robert Jauss, which is more complex than Gombrich's psychology of style, suggests specific directions for empirical research. With its help the history of forms may be integrated into a historical process in which not only works but also people appear.[62] Reception aesthetics sketches out historical sequences in which a work is bound not only to its original audience, and not only to previous art, but also to future artists or works. Each new work of art is confirmed or corroborated against a "horizon of expectations." In this way production and reception together effect the historical transformation of art. Above all this procedure brings the original beholder together with the contemporary beholder: the one as cause of the work, the other as source of the question posed to the work. Accordingly, in the "perpetually necessary retelling" of art history, in Jauss's words, the "traditional evaluation and the contemporary testing" of the work must coincide.[63] The contemporary interpreter is now influenced not only by the "historical succession" of earlier interpreters but also by his own experience of art. In this way the inquiry con-

The End of the History of Art?

stantly finds new directions. With this we arrive at a further aspect.

4. Contemporary art not only violates the frontiers of aesthetic autonomy and repudiates the traditional experience of art but at the same time seeks renewed contact with its own social and cultural environment, resolving thus the celebrated conflict of "life and art." One might single out an analogous tendency in recent art historiography, that trend toward an integral view of things known under the motto of "art in context."[64] Studies of this kind disclose in historical art precisely that "grounding in life" which contemporary art is so eager for, or show how this relationship to life was later displaced or ideologically deformed. Hence the new attention on the part of historians to the "seam" between art and life.

5. Another experience drawn from contemporary life is the increasing familiarity with technical information and its manipulation through the mass media. This has edged the problem of language and media in general, in ideological as well as theoretical forms (e.g., semiotics), gradually into the foreground of the social and human sciences.[65] This is not to suggest that historical works of art should be mechanically interrogated as if they were modern media systems, because in the past they functioned altogether differently. On the other hand, the common study of language and art can certainly illuminate historical systems of symbolic communication. Interest in nonverbal languages is growing and correspondingly the understanding of images in conjunction with language finds ever more currency in the dialogue among the disciplines. Art may even be understood as another sort of language. With this I do not mean the conventional metaphor of a poetical "language of art" but rather a system of symbolic communication locked into the forms themselves.[66]

It is no longer necessary today to justify our interest in media, linguistic systems, and symbols. We are sur-

rounded increasingly by images, signs, and sounds with unsettlingly wide ranges of effectiveness, in which, as Susan Sontag in her book *On Photography* detailed, the frontiers between reproduction and reality, medium and fact are blurred.[67] Contemporary art, too, which responds to similar experiences, is reflecting more and more on symbolic systems—whether images, words, or numerals—which throw light on problems of perception or suggest a new kind of technical "reading." Modern art early on began the challenge to familiar formulas of seeing and perception. Contemporary art extends this inquiry with its analysis of advertising and other public media, which today all too often replace nature as the dominant experience of our world. In such an environment it is surely legitimate for art history to investigate formulas of perception and media in the historical material, too, though under all necessary precautions.

6. The retrospective on historical art possible today reveals aspects of this art which were simply not yet apparent earlier. In any empirical discipline, the permanently shifting reception of the object of inquiry invites a constant revision: every generation, in interpreting the object, appropriates it anew. Precisely that lack of a social role which distinguishes contemporary from traditional art sharpens our sensitivity to prior functions of art. This discontinuity between the two is not eliminated by the mere fact that art is still produced today.[68] Rather, this experience conceals the widening gap. It betrays itself in the permanent self-analysis of contemporary art, which has so long been dominated by questions about the very purpose of the production of art. Self-analysis in the sense of self-doubt and even self-criticism—which so often accompanies the consciousness of inherited art history as a burden—is not to be confused with traditional self-reference as described above (pp. 28–29). In such a climate the questions about the functions of historical art assume a special

urgency. Perhaps one day yet a universal history of art will be conceived along these lines.[69] This would no longer be a morphological sequence of masterpieces and styles but rather a succession of societies and cultures, each with a different repertoire of forms and functions of art.

Our sensitivity to this problem has been more acute ever since art, in Harold Rosenberg's words, confronted "the dilemma of its own existence in an epoch of new media that have assumed most of art's functions."[70] Already in 1950 Jean Cassou argued in his book *La Situation de l'art moderne* that the medium of film "corresponds most exactly to the modern mentality." It fulfills the function "which the public ascribes to art, namely to erect an image of the reality in which it lives."[71] This voice harks from the era of "abstract art as universal language."[72] Since then pop art and the "nouveaux réalismes," up to and including junk art and hyperrealism, have invaded altogether new domains of contemporary reality; as a result the frontiers between "art" and other media have only been further disturbed. In our context this means that art once again, albeit with controversial methods and results, has regained a certain faculty for articulation in face of the world, a faculty which it seems no other medium is capable of replacing. To be sure, these are only experiments within a confusing diversity of contemporary notions of art and other media. The art market and world of collectors only succeed in further obscuring the role of the "visual arts" in our society.

Such insights are bound to affect our perspective on historical art. Even the existence of art can no longer be simply taken for granted, without asking how it came into being or to what tasks it was set. The observation that art once fulfilled other functions than it does today, or that it may have subsequently surrendered some of those functions to other media, suggests a new repertoire of topics for historical research, a repertoire which has of yet hardly

gained a foothold in the discipline. As long as art was considered a natural mode of expression for every epoch—which to be sure has stood in question since Hegel—one needed only to recount its history and extol its achievements, or, as the case may be, lament its current loss. Since we no longer enjoy this confidence in the eternal presence of an immutable art, there is far more justification for curiosity about the earlier history of this art. For only something which is not self-evident mounts real challenges to the understanding. In this sense the newly recognized historicity of art calls for a new audacity, a willingness to penetrate into realms long declared off-limits by the idealistic tradition. At the core of this project is the restoration of the bond between art and the public which makes use of it, and the consideration of how and with what intentions this bond determined artistic form.

9. Art History and Modern Art

Any unified account of the history of art must find room for modern art. Yet conventional introductory textbooks often give the impression that modern art does not exist at all. In the bookstores, meanwhile, it seems as if only books on modern art are published. Evidently the two types of literature have little to do with one another. The reasons for scholarship's neglect of modern art are manifold. The "discontinuity" of which we have spoken commenced not only with the desertion of the traditional genres and the repudiation of the concept of art which they embodied, for example in the first "actions" of Marcel Duchamp. It is equally apparent in the so-called abstract art, which seemed to have renounced art's rightful object. Art historians for the most part declined to take part in modernism's challenge, a challenge which might have inspired a radical reexamination of the orthodox account of Western art. Instead they placed themselves at the mercy of art crit-

ics, who tended simply to propagate or repeat the slogans of the avant-garde.

Granted, Wölfflin published his "grammar" of the abstract qualities of form simultaneously with the appearance of the first abstract paintings. Yet he took no concrete position on contemporary art.[73] With exceptions such as Nikolaus Pevsner or Meyer Schapiro, virtually all those art historians who have molded the profile of the discipline steered clear of modern art. Those who did confront modernity either failed to develop general models of interpretation (on the level of Wölfflin's "Grundbegriffe") or else practiced two different models of historical treatment simultaneously. Thus to the rupture of art in the modern era corresponds an analogous breach in art-historical scholarship. Conservative voices, to be sure, used to lament the betrayal of tradition in modern art, and thus admitted recent history to their accounts as an unfortunate aberration.[74] The champions of modernism used tradition in the opposite way: to justify the new in terms of the old. But even they did not continue the history of art "under the unity of the problem"; still less did they ask how modern art might have altered our understanding of premodern art.

We are always given the impression that one history of art ends just where the other begins. The "second history of art" had its zero hour under the spell of early avant-garde criticism and in the proximity of the *Refusés*. Since then modern art has certainly been historically treated, and with the greatest meticulousness. It is left to a few minds with imagination, and with a faith in the perpetual metamorphosis of an eternal art, to make sense of the process as a whole.[75] In the end this history is still just as distinct from the traditional history of art as the artists themselves wanted to be from traditional art. But ever since the avant-garde itself became tradition, the historical

35

model for the treatment of modern art which it inspired is no longer binding. Thus an art history becomes possible which shares neither the sacred ideals of the old art history—whether of classicism in Renaissance art or of the spiritual power of medieval art—nor the faith in an unceasing progress of the modernist art history. Instead art history is free to measure tradition against the modernist critique, and at the same time to hold modern art up to the canon established by tradition; above all it can remove the barrier between the two, a barrier which only conceals false diagnoses on both sides. The time seems particularly ripe for such an endeavor, now that so many facts have been accumulated, again on both sides, which contradict the familiar patterns of understanding. This situation has only made it clearer that the two art histories have been sustained by different traditions of evaluation and narration, traditions which are fundamentally incompatible. The premodern tradition, isolated by the wall of modernism, became either obsolete or sacrosanct, while modern art itself seemed only to consist of denials of tradition, to such an extent that its response to tradition, where this did occur, was no longer even perceptible. In the meantime it has become clear that the "tradition in the new" was just as important as Harold Rosenberg's "tradition of the new."[76] We are led to wonder whether it might be possible to apply similar standards and address similar questions to both older and modern art.

Indeed, something very like this was undertaken earlier in the century, although under different premises. When modern art (from impressionism to cubism) had its first impact on art-historical writing, its integration seemed simply a matter of adopting the proper perspective, possibly a new perspective, on the previous history of art. The rupture between tradition and modernism would then figure merely as another phase in art's never-ending cycle of

transformation. To this end Julius Meier-Graefe traced the "evolution of modern art" back to the Renaissance and beyond.[77] Werner Weisbach, following up on the ideas of the Vienna School of art history, found impressionism to be a general "problem of painting in antiquity and modernity"; he insisted on the unity of artistic problems and thus of art as such.[78] Modern art did not betray but rather perpetuated tradition. And a constant notion of art promised to safeguard art history's object. It was left to a handful of historians, such as Max Dvořák, to warn against the comfortable fiction of an eternal art: for in fact the very concept of art, Dvořák pointed out, was subject to historical change.[79] Nevertheless the idea of a "continuous chain" of evolution—as Hans Tietze phrased it—remained popular. Tietze, for his part, shifted the discussion to the problem of our own attitude toward historical art, altogether different from our attitude to yesterday's modernism, and again different from our attitude to truly contemporary art.[80] But then the aesthetic appreciation of older art (via modern experience, as Tietze saw it) is not precisely the problem under discussion here, the problem facing contemporary scholarship.

A generation later it was no longer possible to deny that modern art had deserted the familiar territory of older art, be it the content of traditional iconography, the unidirectional evolution of style, or the mimetic function. Meyer Schapiro could relate the old and the new only by positing an irreversible "revolution" and by abandoning any dreams of harmony.[81] The "self-sufficiency of forms and colors" was no product of an orderly evolution but rather the desperate self-expression of the individual in the face of modernity. Paintings recalled tradition by remaining "the last hand-made personal objects within our culture." But they no longer served communication, and even consciously resisted mass communication. Instead they offered a last

refuge for "communion and contemplation," an argument (and a concept) borrowed from nineteenth-century romanticism.

Schapiro was describing in these remarks of 1957 an actual episode in modern art: the emotional fundamentalism of the New York School. Only a few years later technology and mass culture reappeared in contemporary art. The self-reference of art, and thus the built-in retrospective on tradition, gave way to a reference to the culture of advertising and technology, especially in the United States, where European traditions sooner lost their dominance. The notion of a "pure art"—together with "anti-art" as its mirror image—dissolved when artistic products, whether displayed in museums or not, came to resemble applied art or everyday objects.

The question of what art has been in history, and whether it at all resembles this historical entity in our own time, hinges on our understanding of modern art. Scholars' answers will differ according to respective backgrounds and dates of publication. Werner Hofmann, in his 1966 book on "the foundations of modern art," takes a conventional postwar position when he draws attention to the "great realism" and the "great abstraction" culminating in the 1920s.[82] This double-sidedness of modern art, directed either toward modern life or toward "pure art," reflects in his view the dual heritage of Western art, which after centuries under the Renaissance ideals of illusionism and mimesis, discovers a new "affinity" to medieval art. In fact, already in the 1920s medieval art had been called in as a justification for expressionism and, in general, for spiritual values in modern art. But clearly the argument is of extremely limited applicability, for it rests on only a partial analogy. Hofmann's arguments, despite his protests to the contrary, still revolve around formal structures and their transformation. Ten years later Hofmann expressed second thoughts about the official image of mod-

The End of the History of Art?

ern art, as it had been glorified by the commentators of the avant-garde and collected by museums.[83] He concludes that the orthodox account of a progressive evolution no longer offers any stable orientation, and that the concept of autonomous "art," along with its rank within our culture's system of values, has lost its clear outlines.[84] Again, the problem of how art history is to "explain" the continuity of an ongoing history of art appears unsolved, or even no longer solvable. And if it is unsolvable, then the consequences for our retrospect upon previous models of art historical narrative will be grave. We can hardly close our eyes to a contemporary confrontation with the inherited subject of our discipline—art—for the mere reason that it presents us with problems of a new and unwelcome sort.

■

This call for a synthetic treatment of older and modern art, which is by no means yet a program, already begs a number of objections. Is it at all possible to embrace in the same conspectus traditional and modern art, so profoundly divided? And what does one gain in the end beyond a confirmation of their differences? In order to meet these objections we ought to characterize again the dilemma of the contemporary interpreter.

Traditional and modern art are certainly not to be thought of as a single entity. Rather, they should become the object of questions which, by virtue of the retrospective view possible today, admit them both as historical phenomena. Once they *both* become tradition and no longer bear witness against each other, we are relieved of the burden of playing them off against each other as cultural symbols. We can no longer labor under the illusion that we still "possess" or "represent" modernism, but rather must acknowledge to ourselves that we have already attained a historical distance from certain aspects of modernist art, a distance which until now we have only been accustomed to

with older art. This does not mean that we are to level off the gradient between older and modern art, as postmodernist art sometimes seeks to do. Rather, that gradient can only really be surveyed when the interpreter must no longer seek upon it a standpoint for himself and his personal aesthetic convictions. Once the opposition against tradition becomes itself tradition, traditional art no longer appears in the same light. One cannot appeal to modern art unchallenged, because it no longer leaves us with firm convictions of what "art" is. At the same time we must dispense with the notion of a closed canon of classic art as it appeared to nineteenth-century eyes. The reflection on art which is possible today alters the image of art which was handed down to us with the history of the discipline. It is now being asked how art came into being in the first place, and what it was meant to be in other cultures and societies. New questions emerge whenever the old, easy certainties falter: questions which have never been asked before, never subjected to the familiar tools and procedures of evolutionism, biographical analysis, or iconology, questions which therefore guarantee no safe answers. Such questions will probably never profit the art market or the organizers of exhibitions, for their answers will not oblige anyone to change the labels on works of art.

Art history's difficulties with modern art date back to the early nineteenth century, when art lost its traditional public functions. Art compensated for this loss with a reflection on its own aims and means, on the artistic realm. It justified its survival by insisting on absolute autonomy. Art history emerged at the time as a new branch of humanist scholarship, and appeared to follow the same path, isolating the artistic realm as its object of study. But this impression is misleading. For in fact art history undertook to canonize the very tradition which the living art of the time was trying to decanonize. Art history's intentions seemed to resemble those of art; in fact they were applied to

The End of the History of Art?

historical instead of contemporary art. Art history strove to restore the values of a lost tradition, while living art either escaped the inherited canon by means of a deliberate modernism, or else made this canon the very object of its reflection, of its comments, doubts, and desperate affirmations. The two projects shared only their faith in the genius of the artist; they parted ways when art history first explored the evolution of national schools and sought universal principles of artistic creation. Clearly such contrary aims would not lend themselves to an easy synthesis.

But this is only part of the problem of evaluating art from before and after 1800. An art which is already produced under the welcome or unwelcome awareness of its own history, which it then seeks either to escape or to reapply, is not very well suited to an art history interested in demonstrating stable principles or evolutionary patterns. What the modern artist either emulated or rejected (for example the ideal image of the Renaissance artist), the new art historian hoped to make accessible as a living reality by providing historical information and reliable tools of aesthetic appreciation. The possibility of applying this art history to Ingres instead of to Raphael was never even raised. It was left to art criticism to fill the gap, at least until art criticism itself, much later, was embraced by art history as a source for a historical treatment of modern art.

Another problem is best illustrated by comparing art history to modern literary history. The latter has explored Mallarmé's concept of a new poetic language or the vicissitudes of the modern novel—to offer only two examples—in view of the structure of the modern mind, and with considerable success. Literature, to be sure, has never been threatened by the loss of its medium, that is, language as a common denominator. In the visual arts, by contrast, the tableau and the statue lost their status as stable media; indeed, the activity of painting itself and even the notion of personal creation found themselves in jeopardy. Surely

such a radical disorientation might have inspired art historians to a more meaningful engagement with the problem of modernity in art. Just the opposite is the case. The transformations of modernism—from symbolism to cubism and so forth—seemed so self-evident, so self-explanatory that they apparently required only a description of changing artistic means. This description was undertaken for the most part as an appraisal of a continuous chain of innovations, neatly labeled and classified according to the accepted system of "-isms." As long as the continuity and unity of art remained unquestioned, this evolution invited little further reflection.

This judgment may seem unjust and unjustified. But the disparity between literary history and art history can hardly be ignored. This is not the place to examine the reasons for their astonishing incongruence. It suffices to point out that art history has rarely strayed beyond the borders of the system of artistic phenomena as such, and has rarely connected this sytem with the general experience and consciousness of the modern mind or personality. Why else do literature and the visual arts occupy such unequal statuses in the general public's evaluation of modernism? Art in the early nineteenth century, very much like literature, was expected to embody what the individual in the modern age had lost, by positing a fictitious universe with access to private experience. These circumstances prepared the way for many of the startling turning points and apparent contradictions which were to follow. There was soon no longer even a consensus over the definition of art. In the mutually exclusive concepts of art, in the distinction between applied arts and artistic autonomy, was mirrored the pluralism of modern society. By now all these are accepted truths, yet they have scarcely molded and shaped the general discourse; indeed, they have not even established a common ground for scholarly discussion. It is precisely this situation which is our topic here.

In remarking on the coexistence of two art histories which only too rarely refer to one another, we implied that the experience of modern art would be profitable for the study of older art. Indeed, the emergence of modern art must not be mistaken for an accident without repercussions for our understanding of art in general, and of historical art in particular. The nexus between the one and the other becomes all too apparent when one considers modern art's reference to the world, indeed, its own commentary on modernism as a historical epoch. The same reference to the world can also be expected with new confidence of older art, for in fact precisely this faculty of reference was bequeathed to modern art by older art. To be sure, such a reference cannot be distilled to a simple formula. That too we have learned from modern art, whose myriad variations correspond to the high complexity of the modern world itself. In premodern art as well the reference to the world was embodied in numerous alternatives which simply cannot be grasped with the monolithic conceptions of closed artistic styles, such as Romanesque, Gothic, or Renaissance.

With this we arrive at the problem of the alleged unity of older art versus the fragmentary nature of modern art.[85] This apparent opposition, although we accepted it above, is only partially valid. For it is nourished by an all too idealistic conception of traditional art, one which we owe in large part to romanticism. In fact, older art emerges as a sum of rival and complementary functions and their respective expressions. Already in the seventeenth century, in Protestant Europe, art sustained a major crisis. On the one hand, the Reformation had discredited the traditional religious image. On the other hand, the self-sufficient work of art, the modern tableau with its self-contained systems of symbolization and idealization of the world, was establishing itself as a value of its own. The citizens of a Dutch town fostered art on premises altogether different from

those current at the French court. England, meanwhile, in the process of recovering from a long period of artistic provinciality, revealed in the eighteenth century a surprising consciousness of problems inherent in the "great tradition" of aesthetic ideals and official categories of painting. Indeed, whenever we take a closer look, we discover conflicting conceptions of art and of its application. We also discern a narrow interdependence between artistic norms and general cultural convictions. If we take such discoveries seriously, we are obliged to recognize two general attributes of the premodern work of art: its status as an image of the world in which it originated, and as an image of art, an image which confirms, alters, or rejects a certain notion of art. Art collecting only offered the artist's creation an additional raison d'être, one which in turn had its own effect on "art" as such.

It is this double procedure of connecting and disconnecting old and modern art which helps us gain a more coherent, and yet still distinctive, picture of the peculiar phenomenon of art in Western culture. This procedure might be clarified, and our argument brought to a close, with some examples. The general disintegration of categories and boundaries which modern art has encouraged (mixed media, collage, montage, object art and its antithesis performance art) only heightens our alertness to the categories and boundaries of premodern art. The easel painting, a relatively recent product of the European tradition, is a pertinent example.[86] Now that its monopoly has ended, the question of its genesis is more interesting than ever. Those strict categories of genre (such as landscape or still life) or medium (such as wall painting, mosaic, or bronze casts) which collapsed under modernism had in most cases existed only since the Renaissance, and not yet in the Middle Ages. The rupture of modernism was, however, not confined to matters of form and medium, but also involved cultural norms. The role of court art, and the pe-

culiar status assigned to the court artist, is a case in point.[87] This particular story ended when the salon, in its context of public competition and printed art criticism, emerged as a major cultural phenomenon, only to be succeeded by the museum as the ideal destination of uncommissioned works of art.[88] Classical antiquity, meanwhile, only became more conspicuous as its role in art began to diminish. Antiquity always had a double influence on European art, by providing a norm of what art was to be, and be erecting a barrier against what art was not to be. Often art or architecture served the sole purpose of conjuring up antiquity in tangible form. The career of the statue (in its context of sculpture court or landscape garden) is the best example; the nineteenth century's predilection for monuments, and the strange debate over the requirement of nudity for statues, is a most intriguing manifestation of crisis. The last universal European style, of the late eighteenth century, was a last obeisance to antiquity as general cultural norm, and at the same time a last bid at a truly official and public art.

Such examples suggest answers to our earlier questions, questions which became possible only from a standpoint overlooking both premodern and modern art. Familiar manifestations of art look different once they have lost general acceptance and have been replaced at least in part by photography and film. What has ceased to be a self-evident norm can be examined with a new curiosity, with a detachment which reveals continuities as well as discontinuities. The synopsis proposed here is certainly not intended as a quest for the lost unity of art. On the contrary, it only promises new insights if this notion of unity—so dear to a discipline eager to justify its own existence—is abandoned. Our object ought instead to be the diversity of art as manifested in its ever-changing roles and definitions in history. This diversity may well help us toward a broader notion of art, or of different arts; it also characterizes our own situa-

tion, one marked to such a degree by the experience of loss and change. Thus a synopsis of premodern and modern art could contribute to a historical reexamination of modern art.

10. Tradition and the Modern in Contemporary Art

This synopsis as just postulated, however, does not yet include contemporary art or experience of art, which in the following pages we will attempt to distinguish from yesterday's modernism, or the "classical modern." This is an altogether different topic which is related to our previous argument only to the extent that such a distinction between "modern" and contemporary may prove a necessary precondition for a historical perspective on some aspects of modernism. If such a retrospect is indeed possible, then it means we do occupy a different position, one all too often described with the fashionable and problematic term "postmodernism," to which we will return later. The discussion of our contemporary condition is no longer especially a scholarly question and no longer presents art history with a particular agenda. Rather, it leads to a much larger problem linked with the issue of modernism, the problem of self-definition. Of course we all want to be modern: but modern in what sense? Let us restrict the discussion, for the moment, to the experience of contemporary art.

Two very different appraisals of modern art, which expose all too clearly the difficulties involved, may serve as an introduction to our new topic. In her book *Progress in Art* the American artist Suzi Gablik advances the thesis that art has evolved to its highest and most authentic form only in our own century.[89] This is not a new idea: Herbert Read propounded it long ago with considerable fervor.[90] But unlike Read, Gablik relies on a theory of the development of the human intellect, appealing in defiance of the structuralists to Piaget's experimental psychology. Mankind is supposed

The End of the History of Art?

to have undergone a mental development from figurative thought toward abstract and operational thought, just as it occurs in childhood. In its late stages, according to Gablik, this process is reflected in abstract art, with its complex organization of formal logical systems. In the modern era, art, after transcending the boundaries of sensory experience, tended like all cognitive systems toward greater complexity and higher levels of organization. To be sure, this argument is pursued through the example of spatial representation in painting, and thus represents the point of view of an artist who sees the history of art culminating in her own time. But other interpreters (for example Read) have also argued that art, liberated from its original functions, has only now attained its rightful status and is in the position to fulfill its true potential. Between the interpretations of modern art as the fulfillment and as the loss of tradition there is of course no compromise.

The second voice which I would like to cite, once again, is that of Hervé Fischer, an artist who insists that modernism in its traditional forms is exhausted, and who attacks the concept of the avant-garde as an ideology because it demands linear progress forward into the myth of the future.[91] Fischer considers art as we know it a phenomenon of the past: we must escape from it and "penser hors culture." Thus he conceives a "Hygiene of Art" which is supposed to "demystify" the sacred ideals of art enshrined in current aesthetic theories. Instead of remaining isolated in the "art scene" the artist should address himself to the public at large and become the pedagogue of a new society.

Fischer touches on the theme of the history of art only in declaring it to be finished: art history can only be further practiced archaeologically. To be sure, he draws strange conclusions; but in the end Fischer belongs to that vast chorus of commentators on contemporary art who understand modernism as a completed cycle. As Fischer formu-

lates it, modern painting developed an "internal critique" which ended up carrying painting to its conclusion. This began with dematerialization and the reduction to the pure idea. We are witnesses to a "death ritual."[92] Against a self-criticism which denounces art in its own medium, develops an "artistic scholasticism: art as a commentary upon itself. . . . The commentary is valued higher than the work."[93] Artistic movements such as the so-called art about art quote historical works of art in order to comment critically or positively upon them.[94] The escape from the conventional genres and media, even from the category of the "work of art" altogether, is only the other side of the same coin. Fischer's conclusion is not merely contrary to Suzi Gablik's: rather they are talking about two quite different things. Though they both speak of modern art, Fischer applies this term to contemporary manifestations, Gablik to "classical modernism." We should be wary of this confusion and turn directly to the contemporary situation which Fischer, in his own way, is describing and commenting on.

■

The new state of consciousness resulting from this most recent "crisis of art" articulates itself among artists and public above all in the themes of avant-garde and tradition. Their usual antithesis is no longer found to be convincing. In order to comment on this shift in consciousness it does not suffice to quote the refreshingly clownish Hervé Fischer. The situation was more acutely analyzed by Harold Rosenberg.

In his polemical book *The De-Definition of Art* Rosenberg argues that art is not moving forward either as technological progress or as a stylistic development, nor will it achieve any longer the sort of solutions which will in turn generate further artistic problems.[95] As soon as art is pinned down to such goals or solutions, then the "end of

the line," as the poet Randall Jarrell put it, looms into sight. In the "ersatz avant-garde" nostalgia rules, ever since the "adversary culture" which the avant-garde once claimed to represent disappeared. That happened at the very latest with the arrival of pop art. "While art today is not avant-garde, neither has it been absorbed into the system of mass culture. . . . The present art world is rather a demilitarized zone." In this "buffer area" art finds itself "immune to attack by both vanguard intransigence and philistine prejudice. . . . In the aesthetic D.M.Z. all art is avant-garde. . . . All the advanced art modes of the last hundred years now constitute the modernism that is the normal mode of expression for a wing of popular taste."[96]

Yet things change so rapidly that even this most clear-sighted view is no longer entirely accurate. Rosenberg's "ersatz avant-garde" in the meantime *has* been absorbed into mass culture. The pretty and the decorative are central preoccupations of contemporary art, as are technical surprises, machines and their products, simple-minded entertainment art, or art as entertainment in the ordinary sense. Their opposites are the ever-new variants of concept art, art reduced to an argument in visual form: gestures of thought which avoid any all too tangible reference to the material category of the *oeuvre,* or which use the latter as a disguise for making a statement.

Another development, likewise antithetical in structure, seems even more crucial in our characterization of contemporary art. On the one hand, we observe a decisive trend toward the anticultural, the banal, and the casual which revolts against modernism in its most sacrosanct and hermetic self-definition. The ugly, in this context, is not terrible but disgusting, anarchical, defiant of any system of cultural values. The ugly is also intended to be ugly in an aesthetic sense. This current of contemporary art is in apparent contradiction to itself, for it is still labeled as art although it abhors any known definition of art. And yet we

find a counterpart to all this in the nostalgic retrospect on past manifestations of art. Art redefines utopia as a backward view on better times, and culture as a mere memory of what it had been. Here art history comes into play, and with it the view on tradition.

In his book *The Anxious Object* Rosenberg addressed as well this second theme in our argument: the evaluation of tradition in contemporary art and among the art public.[97] Here he makes a distinction between the familiar understanding of tradition—which has been lost—and a new historical consciousness which has taken its place: an awareness of art history which not only the beholder but indeed every new work shares. It demands constant innovation as much as clear references back to a history of art, a history toward which the work takes its own stance. The content of a modern work of art is guided by reflection on the history of art. Often this reference is "the *only* content." At the same time every work becomes a candidate for a future niche in a continually written art history. The most prescient collectors, recognizing this, are already preparing for the "comeback."[98] The public enjoys the sensation of actively taking part in the history of art, and is convinced that it will be judged one day on the extent of this participation. Not only artists but also critics and museum officials participate in "the attempt to *make* art history": the catalogs of Alfred Barr, Jr., for example, the former director of the Museum of Modern Art, had become already in the 1930s a chronicle and catechism of the avant-garde.[99] "For the artist," writes Rosenberg, "the replacement of tradition by historical consciousness compels a continual choosing among possibilities. The decision to follow one esthetic hypothesis rather than another is a matter of professional life or death. The release of art from the one-way push of the past is inseparable from a permanent uneasiness, related to the anguish of possibility from which all free men suffer."[100] Since Picasso, who in his own way an-

The End of the History of Art?

ticipated this, art is "collective property from which the individual is entitled to draw as much as he can use," and which he can comment upon and thus appropriate to himself: the quotation becomes the vehicle of new artistic statements.[101]

This observation was of less general bearing when first published than it is today. For since then our entire culture has adopted the strategy of statement by quotation. The chosen style, like an actor's mask, disguises the speaker and instead recalls another who has spoken with more authority and better command of the language. A general fascination with performance, the staging of past themes and styles, is another peculiarity of our epoch. Our virtuosity in performing in the technique and in the spirit of the original is not restricted to the concert hall and the theater. The need to appropriate what is lost through performance is related to the desire to twist a previous argument for the purpose of reusing it in a different sense.

In retrospect, the original or unique creation appears to belong to an age of individualism. Fernand Léger remarked on this phenomenon and envisioned as an alternative a new public art.[102] Instead the original creation has only been replaced by its imitation and multiplication, not only in the visual arts but wherever beauty and meaning are still under consideration. Images circulate as replicas and as quotations. Their provenance is universal, their use out of control. Inflation reveals the loss of validity. And their unlimited consumption undermines our notions of reality. We obey images, according to Roland Barthes, rather than ideals of ethics or religion.[103] This general "imagomania" inevitably alters our attitude toward historical art and its contemporary reapplication. The old sometimes seems more accessible than yesterday's modernism. Oddly enough, it is precisely the anachronism of poetry and the beaux-arts which endows them today with their most important function. The historicism of

contemporary art is no mere accident but rather inserts itself into a general pattern of cultural behavior. The dangers, too, are obvious. In a situation where anything goes, art history could offer itself as a fixed point of orientation, stubbornly maintaining a position amenable to the notions of individual styles, artists, and works of art. But let us consider still another side to the contemporary reassessment of historical art.

■

The return to historical art and to classical modernism, whether in artistic commentary or in a new edition of the "-isms" (neo-avant-garde, post-avant-garde, trans-avant-garde), involves a deliberate retrospect on the road which art has already covered. Thus the production of art becomes either a sort of applied art history or, in resistance to this logic, a deliberate and radical effort to escape the historical legacy. Both reactions, however different their results, bear witness to a general awareness that the path along which the old, familiar art might have continued, into a yet unknown future, has come to an end. To dismiss all this as nostalgia or as a loss of nerve would be to underestimate its significance. In non-Western cultures, such as those of the Far East, we find a highly developed awareness of the limits of a tradition of art, of the early completion of a canon. Indeed, one of the questions which the condition of contemporary art raises is whether we have run up against the limits of the medium of art in Western culture (the enthusiasm for primitive cultures in early modernism demonstrates that the awareness of this problem is hardly new). If this is so, then not only would the "internal critique" of art of which we have spoken make perfect sense, but also a reevaluation of the history of art: a history which suddenly becomes available as an achieved entirety.

Such a thought seems incompatible with a conventional Western mentality, where the ideals of progress and utopia

still occupy center stage, encouraging a dynamic image of the world and inevitably investing objects from the tradition with the staleness of the old-fashioned and conservative. Modernism, with its avant-gardes and technological advances, has dominated our cultural consciousness for so long that Jürgen Habermas has even delivered a spirited plaidoyer against its recent fashionable discrediting.[104] If modernism refuses us the accustomed orientation as cultural norm, we are deprived of the fundamental symbols of our self-understanding. It is difficult to imagine a different perspective—such as the view of the entire history of art including modernism, with the renunciation of value judgments—without sustaining a cultural disorientation. And yet contemporary art is doing precisely this. It is developing a new, almost irreverent informality in its dealings with the tradition. The same possibilities are available to art-historical study, and can even foster a critical revision of its questions and theories.[105]

This is not to propose that art historians imitate artists. Indeed, their purposes and interests are altogether different. For while the contemporary artist arbitrarily appropriates works from the past, the art historian must insist on the unique, historical profile of those same works. In recommending that art historians take notice of the contemporary art scene, we mean simply that it should be possible for art history to join a discourse already initiated by artists on the nature and function of art, or rather, of manmade images invested with the customary dignity of art. Such a discourse today seems to cluster around two poles: the definition and structure of images throughout history, and the problem of the visual and mental reception of such images by the historical and the contemporary beholder. Such topics of discussion have been accompanied by a new curiosity about past creations, a curiosity which we might even characterize as "postmodern."

To be sure, one drifts easily with such thoughts into the

pull of a fashionable and not necessarily desirable current. As of yet it is hardly possible to distinguish a new state of consciousness from its modish expressions and applications, which in this case must appear especially odious to the loyal defenders of modernism. Indeed, there is a great deal of kitsch and nostalgia about. The "monument euphoria" in the wake of Europe's "Year of Historical Monument Preservation" (1975) and the sprouting of postmodernist architecture are symptomatic. This represents on the one hand an argument *against* modernism, on the other hand a leveling process, in the sense of making entirely available anything we happen to come across and thus forfeiting our capacity to make evaluations. Though this current is by no means restricted to architecture, it is here that it first met with general attention and generated a detailed discussion, a discussion which it might be useful to summarize here.

■

The program of a "rational architecture," which drew models for the residential domain out of the humanistic tradition, was directed against Bauhaus ideals and functionalism in modern architecture.[106] Already in 1969 Aldo Rossi spoke of an "architecture of reason," theoretically grounded in "the philosophical rationalism of the Enlightenment," which sought to reconstruct functionally and aesthetically the "public domain" of the typical European city.[107] Leon Krier, who soon assumed a leading role in this movement, hopes to link the new forms of building to social and aesthetic "needs," instead of subjecting them to the goals of technology, progress, and style.[108] This overlaps with objections to the formalism and brutalism of modernist architecture, which is to be banished to the shadows as quickly as possible. In the same breath the tradition is glorified. Indeed, one is supposed to assume a "new self-consciousness and openness" toward tradition, implying that until now, because of modernism, one was

The End of the History of Art?

embarrassed by it.[109] The architect James Stirling, who brings old and new together and thus strips the aura from both, dubs modern architecture since Bauhaus "abstract" and traditional architecture in its new adaptations "representational," that is, representing its functions and environments.[110] Everything is available for these new solutions, these "confrontations of different building traditions" for the purpose of contemporary consumption.

The resulting buildings are then evaluated by the critics usually on the basis of their aesthetic appeal, but not as symptoms of a new attitude toward style or form as such. For architectural style no longer testifies *for* progress and utopia and *against* yesterday's conventions. Architects no longer set their buildings against ideals of outmoded architecture, but rather single out historical prototypes which then become available as models.[111] This, too, is an "end of the history of art." The total presence of all building styles leads to their leveling, their montage to a break with stylistic unity, even a break with "style" as a principle in the conventional sense. Architects and their sympathizers thus promise us a new freedom, above all from a modernism that had atrophied to a compulsion, and likewise a freedom in shaping the human environment, in which one no longer recognizes stylistic forms as cultural norms to be maintained, obligatory and pure.

It is telling that the term for all this is "postmodern." The term "modern" is no longer available as a self-description. It refers not to our present but to an already past style, the so-called modernism. It is equally significant that the real nostalgics today are the champions of classical modernism. They hold fast to abstract art as a symbol of modernism without noticing that in the meantime it has "lost its content." (See p. 10 above.) In the resulting vacuum, others, who are secretly pleased about all this, introduce antimodern ideals of art which in fact are only illusory alternatives.[112] The resulting confusion threatens to

discourage anyone hoping to single out the essential problems, or to determine their bearing on our present historical situation.

■

One must live with this pluralism of styles and values which apparently characterizes our society, if only because there is no exit in sight. Where before the loss of tradition was lamented, today the loss of the modern is lamented. Complaints are more common than productive efforts to work with the contemporary state of consciousness and to distinguish it from fashionable offshoots. I have tried to sketch out a framework of possible themes for discussion, and indeed hope not to fall into any sort of apocalyptic cultural pessimism. It is not easy to take up a position in this new broken terrain without immediately exposing oneself to endless misunderstandings. The situation calls for caution rather than for heroic agendas.

Because our argument is essentially concerned with the study of art history, it can end with it. Art history as an academic discipline was established before modern art appeared. It was often practiced alongside modern art, as if the latter did not exist at all. In the meantime modern art has been absorbed as one of its historical objects, without the art historians knowing quite what they should do with this newly inherited responsibility. For the observer who knows what to look for, curiosity about the consequences is the obvious attitude.

A modern mind, existing independent of the creed of modernism, may indeed focus on objects outside modernism. The interpreter must no longer be wary of succumbing to a conservative system of values, such as that which the champions of traditional art held up against modern art.[113] There are new circumstances and possibilities today which invite a retelling of the history of art. The retreat from the "great themes," for example, or the discovery of historical

The End of the History of Art?

man in his quotidian and private environment, reflect developments in the social sciences. In art history these or similar interests need not lead to neglect of the aesthetic phenomenon or of artistic form as an interpretation of the world. But the distinction from the "musée imaginaire" of masterpieces, curated by an exalted interpreter, is clear.

Art history, obviously, is not yet finished as a discipline. But in some of its familiar forms and methods it is perhaps today exhausted. The breach between two kinds of art history, which treat either historical or modern art, and do this under different paradigms, no longer makes sense. We are just as poorly served by a rigid hermeneutic framework perpetuating a dogmatic strategy of interpretation. It is perhaps more appropriate to regard the interrogation of the medium of art, of historical man and his images of the world, as a permanent experiment.

Epilogue: The Issue of Representation

My text deals primarily neither with recent art nor with postmodernism in general. Rather, it singles out problems peculiar to art-historical writing as it is practiced today. The restricted scope of the discussion may be defended on the grounds that it is more practical; moreover, it anchors the discussion within art history's proper domain, and preserves its independence from fashionable discussions taking place elsewhere. Nevertheless, the informed reader will easily recognize patterns of a larger debate within literary criticism and philosophy and thus will regret the lack of concrete reference to the general context. A brief comment, loosely attached to the main text as a kind of epilogue, may therefore be in order.

Art history, as everybody knows, studies vehicles of representation, namely, works of art. But we often forget that art history itself *practices* representation. In constructing a "history of art," it represents art; it endows art with a meaningful history of its own, distinct from general histo-

ry. The "history of art" is a pattern of representation which serves only too well the needs of the art critic, for the critic knows how to make use of its self-fulfilling prophesies. This type of representation "explains" what it needs to explain by constructing a narrative which locates the individual work just where it makes most sense. It thus seeks "truth" of a particular kind by employing a specialized discourse, the discourse of art history.

Art was described and celebrated as an independent branch of human activity precisely by means of a linear, unidirectional history, with artists as its heroes and works of art as its events. This program (which also offered a general framework for the task of the connoisseur) obviously has common roots with other branches of nineteenth-century scholarship which attempted to master the world by constructing history, including the history of the mind. It is equally apparent that this type of scholarship, so central a phenomenon of modernism, can today no longer claim a monopoly but is rather undergoing a crisis: the crisis of representation.

It is the relatively recent loss of faith in a great and compelling narrative, in the way that things *must* be seen, which looms behind much of today's theoretical debate. I refrain from citing names and outlining the leading positions and approaches. Those familiar with the current discussions will not need such data, and the others will not be satisfied with mere allusions but will wonder whether these discussions can justifiably be applied to writing on art at all. It is indeed this latter question which will guide us through a brief reconsideration of two problems which were central to my text: the problem of representing the *history* of art, including modern and recent art, and the problem of representing the single *work* of art within a coherent interpretative strategy.

This latter task, too, is a matter of representation, of

The End of the History of Art?

"representing" the work of art by explanation, commentary, and integration into a historical order. What does the work stand for? What does it prove? The answers have always been judgments made by the historian, judgments which however no longer command a general consensus. The problem begins with what I would like to call the "analogy of mimesis": where what the critic does is linked to what the work of art does. The work was supposed to reproduce either something which was considered real, such as nature, or a truth, such as beauty. The critic, in turn, was supposed to reproduce the work by describing its relation to the content or model it reproduced. Thus he duplicated, or reversed, the work's act of representation by transferring its visual statement to the verbal system of the text. In doing this he would maintain a frontal position with respect to the object of his interpretation, much as the work itself preserved a clear detachment from what it referred to.

This notion of a divided task, between art on the one hand and criticism, as talk about art, on the other hand, breaks down where recent art fashions itself as a kind of "text," a talk about art in its own right. Montage replaces coherent representation by deconstructing the former unity of the work. The "argument" is carried out with the help of references, references not only to fragments of nature, but also to fragments of culture (such as other works of art, photographs, etc.). Thus it is either itself equivalent to an act of "interpretation" or, on the contrary, testifies to the loss of a unified vision or statement. The artist as a consequence aims at being a critic in his own right, though, unlike the traditional critic, he introduces avant-garde means and techniques into his "discourse." He quotes in order to disprove (or alter) the original statement he is quoting, or he combines heterogeneous signs (forms, motifs) in order to "prove" something in a new allegorical, oblique way.

Even to the extent that he does succeed in achieving a kind of discourse, it will not resemble any known types of discourse, let alone those with scholarly ambitions.

As long as the modernist artist was guided by the convictions of avant-gardism, he was able to maintain a fixed distance from premodern art, either by ignoring it or by disparaging it. What premodern art had achieved in terms of mimetic representation (of the world, of an ideal), modern art replaced with immediacy and presence, i.e., presence of the work via its form. Form by itself assumed as much authority as content had before. It implied the autonomy of the "language" of artistic representation. But since then form, too, with its claim to truth and general validity, has fallen under suspicion. The innocence of "doing" representation has vanished; freedom from the binding rules of any type of representation has become desirable.

These developments have also deprived the artist of his fixed distance from past art. He is no longer himself supposed to occupy a stable position within a continuing history of art. As a consequence, he feels free to undermine the positions assigned to past works of art by art history, as they are reflected in the (ideal and universal) order of the museum. Along with his distance from past art he also lost his stance of opposition to it; he now decomposes or reintegrates it just as he wishes, via the techniques of montage and collage. Photography, too—no longer distinguished from painted artifacts but raised to the same level of freely available images—enters the repertoire of his new "visual texts." Finally, the category of the "original," the esteemed object of past art criticism, has lost its profile within contemporary art. As a result, the nature of the copy, of the nonoriginal, of a secondary reference can no longer be adequately defined. To distinguish original and replica makes no sense when everything refers in an apparently arbitrary way to something else, something already present in the

mind of the spectator. If there is still coherence, it now exists in the mind of the artist and the critic and not in the works themselves.

This rehearsal of well-known circumstances reminds us that art history's customary object of study no longer looks quite the same. The object has changed not only in appearance but also in substance and meaning. And with this change the former symmetry of representations—one on the part of art and the other on the part of historical interpretation—is disturbed. Can the latter continue along the same lines when the former is rejecting all the expected responses? The same or a similar break characterizes recent art's relation to past art and its history, its system of values. What art-historical scholarship, with great effort, had canonized—the ideal order where everything obeys the rules of art history—recent art tends to decanonize. This system of hierarchy and historical classification is being raided by artists, who now appropriate past art without bothering to justify their reinterpretation within the ordered discourse of art history. They devise an art history of their own. This leads of course to surprising discoveries in realms where everything seemed familiar, but even more so to confusion. The artist encroaches on the territory reserved for the critic and at the same time rivals the privilege of the historian. His act of representation simultaneously resembles and contradicts the critic's or historian's act of representation. There would be no difficulty were it not for the inconvenient circumstance that this transgression of the borderlines between two territories deprives the critic or historian not only of his proper object but also of his accustomed detachment from that object, an object which he was supposed to be making accessible through his own interpretation.

At this point, the informed reader will object that I have reversed the real problem, namely, the invasion of art by criticism (and, alas, by the art market). Art, in this view,

loses its independence and is condemned to carry out the postulates of an all too possessive criticism; for criticism tends to govern art according to its own arbitrary convictions. This observation is undoubtedly as valid as my own diagnosis, and indeed its validity could be elaborated on if art were my main concern. Since, however, art history (and criticism) concerns us here, I must insist on the problems I have chosen for this epilogue: art history (as a system of representation) vis-à-vis recent art, and the relation of interpretation and the work of art.

The problems have been discussed at large in the camp of literary criticism. The most extreme solution demands that the critic reverse roles and imitate the artist. If the author disrespects the boundary lines between literature and mere language (the tool of the critic), the critic may in turn adopt avant-garde techniques (such as the montage of surprising quotations) to convey his message instead of operating strictly within the ordered discourse of criticism. This view, which I have simplified and even somewhat distorted in such a brief allusion, is more a statement on the utility of a scholarly rationale than a reaction to recent art.

But the imitation of the artist is far from a simple solution and may not even be desirable. In our discipline, moreover, it is frustrated by the inconsistency between verbal language and visual imagery, at least in those instances where this distinction (which is being undermined by the integration of verbal signs into art) still holds true. Art history has not even reached a stage where such a mimesis (the critic or historian as artist) could be an issue. Whenever it does admit that it is facing new problems, it either seeks refuge within the easy confirmations of connoisseurship (which today are supplemented by technical demonstrations of the scientific variety) or occupies itself with social history in order to preserve its raison d'être and to maintain a safe distance from the seductive or threatening sounds of recent art.

The End of the History of Art?

But the problems remain. We are left with the question of what the discourse of art history is to be and how it is to reveal the common features, as art, of recent, modernist, and older art, as well as the fundamental differences among them. The problems have been occasioned as much by the loss of a coherent "history of art" (meaning the history of Western art and not "world art," which we cannot lose since we do not yet "have" it) as by the loss of the eternal "work of art," which demands an ordered and universally valid act of interpretation, or representation.

As we remarked earlier, this allows for a new freedom of approach which is as promising as it is dangerous. It is promising as long as it opens new roads and permits several alternative means of access to the object of study instead of compelling us to exclude any one in favor of another. And it is dangerous as soon as it leads to a general disintegration of coherent methods or approaches. Interest for the singular and particular will only be encouraged by this situation. The object of study (the "work" in the old sense) is not expected to testify to a general system of representation—such as "history," "art," or the "history of art"—but rather to disclose its own particular truth or message, and always according to what the historian is asking of it.

■ Two

Vasari and His Legacy
The History of Art as a Process?

1

THE ASSERTION THAT ART HAS A HISTORY WILL MEET MOST RESISTANCE FROM THOSE WHO BELIEVE THAT ART IS TO BE found only in *works* of art. For every work of art is in itself complete. In its factual existence it is no longer alterable, in its form not repeatable, and in the topicality of its message inextricable from its time. How can such a work be at the same time incomplete, merely a step within a larger development? Indeed, Benedetto Croce and his school rejected any model of a historical development of art and insisted instead on the "insularity" of the work; for them the work was interpretable only on its own terms and not out of a history of art.

The work of art is after all a material reality, art, by contrast, only a concept. But then this concept has been incorporated into the very definition of the work. It encourages us to think of the work not so much as the work of an *artist*, but as a work of *art*. The phrase "work of art" has come to signify an understanding of the work as incomplete and thus historical. For insofar as art has a history, it exists beyond the individual work and thus at least partially invalidates the completeness of that work: on the one hand through the creation of new works, which are always "critiques of past works,"[1] on the other hand through the transformation of the work into a historical phenomenon, whose survival is entirely contingent on its subsequent reception.

I shall mention only two of the possible ways of seeing the work of art within a history of art. The work might be thought of as a station along the part of art, perhaps even helping to determine the course of that path. Or it might be an attempt to achieve or to fulfill an aesthetic norm. If it has not yet fulfilled the norm, then it remains open-ended in the direction of this assumed goal. If the work of art has realized the norm, then it becomes the last stage of an an-

ticipated development, and at the same time the reason for initiating a new development. This second model of understanding has been thrown into question since the nineteenth century. It seems to be only a variant of the other; in fact it is the older of the two. It was the premise for a conception of the history of art which eventually came to serve any number of interpretations.

It seems paradoxical that a norm, of all things, should suspend the static character of the work of art, for any norm is by definition static. Yet a norm can imply movement simply by postulating its own realization. The fulfillment of a norm is only achieved in stages, and thus every result along the way is rendered provisional: as long as it remains unfulfilled, the norm is perceived as the reason for further progress. The most celebrated norm was that known as the "classical": a norm which appeared to have been established in antiquity and which therefore provided the Renaissance with a goal.

I shall have more to say about this particular historical process—the emergence of Renaissance art—later on. In the meantime we might ask who brought this classical norm into play in the first place. Did it actually figure in the historical process itself or only in its later description? Before answering such questions we must account for that notion of "art" as such which was supposed to fulfill the norm. "Art" in this sense was the product of a historical line of thinking; indeed, today, certainly within the traditional visual arts, it finds itself very much in question. The concepts of an aesthetic norm and an art upon which this norm is imposed are mutually dependent. They are both the fruit of Renaissance art and its theory; for "art" became an independent concept only much later than did the skill or "artifice" of the person who produced art. Thus the modern notion of art was prepared by the Renaissance. But then only during the Enlightenment and romanticism would it take on its current meaning. And only when the

Vasari and His Legacy

concept was so far developed could a "history" be written of that which the concept referred to: a "history of art."

Johann Joachim Winckelmann's *History of the Art of Antiquity* appeared in 1764.[2] Strictly speaking it is the first attempt of its kind. In the preface Winckelmann promises not merely to tell stories but rather to write "history in that broader sense which it had in the Greek language." The "essence of art" was the highest possible object of that history. Already in this epoch extreme formulations of "l'art pour l'art" had become possible, as for example when Herder said, "A work of art exists on account of art, yet art itself serves a symbol."[3] And Winckelmann distinguished his work from earlier efforts thus: "Already several works have appeared under the name of a history of art; in fact art plays only a small part in them." Winckelmann never tells us how much he owes to Giorgio Vasari; and in fact Vasari is the subject of this essay.

The concept of a *process*, which was the topic of the symposium for which this essay was initially written, has long been at home in art-historical writing.[4] An inventory of all the meanings ever assigned to the word, however, would betray its vagueness rather than justify it. The best-known usage does not even belong to our theme: namely, that "artistic process" which generates not a history of art but the work of art. In its artistic practice the twentieth century has attempted to render this process autonomous and thus to burst open the work of art in which is has been, as it were, preserved, frozen, or objectified. For aesthetic theory, too, the "immanent processual character of a work" is to be "set free," namely, through the act of beholding. As formulated by Adorno: "Whatever in the artifact may be called the unity of its meaning is not static but processual."[5]

But the process of genesis of the work of art, like the process of its reception, is something quite distinct from that process of the historical transformation of art which is

our subject here. No one will deny the fact of historical change in the production of art, or in the art produced. It is so to speak the "shape of time,"[6] the "image" of historical change embodied in the corpus of the works handed down to us. The formula for the diachronic difference as well as for the synchronic concordance of works or forms is provided by the concept of *style*. This, too, is a late product of art-historical writing. And originally it too was concerned with norms. As is well known, the old stylistic terms represented negations. They were "masks" for the categories of the classical, which they were defending, and of the unclassical, which they were repudiating.[7] Now they are used predominantly as labels within a system of classification. By themselves they seldom explain anything at all.

The description of the historical transformation of forms usually implies description of a development. Describing the development of an artistic *technique* is today as unproblematic as ever. A technique emerges out of certain preconditions, and develops over a certain period of time. If the individual phases are known to us, then we know the course of the entire development. It is quite different with the development of artistic *form*, which begs definition simply as a phenomenon. Precisely where and how are we to detect the transformation between an old and a new form, or even to define the actual object of the development?

Form is so thoroughly interwoven with the material, the technique, the content, the function, and the purpose of a given work, with the category of object to which the work belongs, that it cannot simply be extracted from the fabric as "pure form," to be compared to other forms for evidence of historical transformation. This is, however, precisely what happened whenever a history of forms, or "vie des formes," was written.[8] The "inner history," as Heinrich Wölfflin put it, seemed more compelling than any of the external or foreign influences on formal transformation.[9]

Vasari and His Legacy

Wölfflin's dictum that "every form works creatively further" carries to an extreme the one-sided model of an immanent formal history.[10]

Wölfflin found the transformation of forms to obey an inner law; this transformation in turn corresponded to a "transformation of the imagination."[11] He conceived of a limited repertoire of archetypes of artistic form which then follow one another in an orderly fashion. Wölfflin, as Ernst Gombrich has shown, was a champion of the classical norm; for all his modern terminology, he still belonged to a tradition which had been presented as a system for the last time in the work of Hegel.[12]

Granted, the model of process belonging to this tradition was no longer employed by Wölfflin. This was the metaphor of the biological organism and its cycle, which in the preindustrial age had been the paradigm for—and at the same time the limit on—virtually every development. The metaphor presumes (as Hegel, still in concordance with Vasari and Winckelmann, formulated it) that "each art has its time of efflorescence, of its perfect development as art," in other words a classical moment, with "a history preceding and following this moment of perfection."[13]

2

Vasari's *Lives of the Artists* is the first post-antique body of art-historical writing.[14] It describes in its own way a process. Though it has lost its value as a historiographical model, the *Lives* merits our attention because it describes a process which apparently actually occurred: the emergence of the art of the Renaissance. Vasari in many ways dominated our understanding of the history of art until well into the nineteenth century, even when he was contradicted. Yet he has been chosen here for still another reason: he furnishes an example of the specific problems of a species of art-historical writing which is still with us today. The answers may have perished but the questions remain.

Legend has it that Vasari found the inspiration for his work in the literary circles of Rome, which were also frequented by Vasari's hero Michelangelo. Vasari was a painter and architect who wrote above all for other artists. In his *Lives of the Artists*, which appeared in 1550 in the first and in 1568 in the second edition, he erected a sort of literary monument to the art of Florence. This allegiance to Florence, which both restricted the selection of artists and dictated the choice of sources, has earned him the accusation of being more of a patriot than a historian—an overhasty charge, for behind the restriction lies a logic which was not Vasari's own in the first place. Florence provided Vasari—a native of Arezzo—with a fixed framework within which he could locate himself. The early development of art in Florence resembled a collective enterprise, or even a mortgage on the future; and in Vasari's eyes, all this promise had been fulfilled by the formation of a classical canon.

Four types of writing on art, all with antique roots, are combined in Vasari's *Lives*: artists' lives on the model of Plutarch's biographies of famous men; rhetorical descriptions of works on the model of Philostratus' *Eikones*; technical instructions in the chapter on the genres, on the model of Vitruvius' recipes; and finally a doctrine of the development of style, which figures in the introductions to the lives, on the rhetorical model of Cicero's *Brutus*.[15] We shall not concern ourselves here with Vasari's sources or with the differences between the two editions of the *Lives*, but rather take Vasari in the second edition at his word. Our aim shall be instead to summarize his description of an art-historical process and to test its reality, that is, to measure it against the reality of what he describes.

The *Lives* is divided into three sections, corresponding to the three epochs of modern art. Each artist stands in a plainly preappointed position in this tripartite development of art: in the age of Giotto or that of childhood, in the age of Masaccio or that of youth and education, or in the

age of Leonardo and Michelangelo or that of maturity and completion. In the introduction to part 2 Vasari appeals to the topos of "Historia magistra vitae": history ought to be so narrated that one can learn from it.[16] The didactic value of the lives was obvious: they were to serve the artists as examples.

The biological model, too, was intended to serve as an example, for in the image of growth it was to spur on and in the image of decay to warn. The biological model is above all the model of a *cycle*. The repeatability of the cycle is implied in the formula of rebirth, or renaissance. In this way the biological model helped define as a natural law the beginning of the modern cycle as well as the end of the antique cycle.[17] In the progress of modern art Vasari saw the rebirth of antiquity. Vasari even believed in a more or less exact analogy between the two phenomena. If one exchanged the names of the artists, one "would find the self-same events" among the Greeks and the Florentines.[18] Nature and antiquity were the ideal types against which the development of art was to be measured: the one provided the natural law of the cycle, the other confirmed that this cycle also applied to art.

Just as revealing as what Vasari accepts in his scheme is what he rejects. Gothic and Byzantine art remain outside the cycle. The "maniera tedesca" is rejected because it seems to lack order, because it doesn't speak the formal language of antiquity.[19] It is so to speak ungrammatical: there is only an *antique* grammar. And it is this grammar which provides art criticism with a set of standards, namely, those norms which Vasari defines anew through the five terms rule, order, harmony, "drawing," and style.[20] We shall return to this.

Only the cycle itself became the object of historical writing; the Middle Ages, which separated the antique from the modern cycle, were only admitted later as the "prehistory" of the latter cycle. Within the cycle everything which hap-

pened was presented as meaningful. Every epoch had here its own collective "maniera," which independent of the individual "maniere" of the various artists was related to an immanent law of development. Style becomes a normative concept, part of the effort "to distinguish the better from the good and the best from the better."[21] In the third age "art has achieved as much as is possible to achieve in the imitation of nature," indeed, has even "conquered" nature.[22] Vasari praises the artists of the first epoch— grouped together "on account of the similarity of their manner"—not in *comparison* to but rather in *view* of the later artists; they are to be judged according to their historical conditions, as pioneers.[23] They were the groundbreakers in the enterprise which eventually led to a perfect art. "Arte" carries the double meaning of a learnable craft and an objective science.[24] For the most part it is still associated either with a particular domain of art (architecture, sculpture, etc.) or with an artist who has mastered that domain. Yet what is said here about art makes it available for the first time as an independent concept, leaves it open for future elaboration.

3

We shall have to be satisfied with this all too brief introduction to Vasari; we must abstain as well from a critique which, after all, has been heard often and thoroughly enough since the romantic era. For it goes without saying that the Renaissance cannot simply be considered a repetition of antiquity. The idea of evaluating art according to its success in mirroring nature became obsolete at the very latest with the crisis of representational art. Indeed, nature itself has become an uncertain reality, an unstable foundation for a definition of art. The breach had already opened in romanticism, when the academic rules for the study of nature were first rejected. But in the end the issue is not so

much what Vasari has to say to us but rather what he had to say about his own time. And with this we move from the chronicle to the events themselves.

Vasari reports these events all the more authentically in that he was a participant and not only a chronicler. Through his own education as an artist he had become part of that very tradition which he later made into the theme of his *Lives*. His testimony consequently reveals how the carriers of tradition understood their own role. Vasari speaks as an insider, a witness for the consciousness of the participants.

This consciousness characterizes a group of artists which found itself together, as Adorno would have formulated it, "under the unity of a problem."[25] Every successful work was a contribution to the solution of the common problem and therefore a step forward along the common road. In understanding art as problem solving we are on the track of an important driving force behind Vasari's Renaissance: for if Vasari understood the course of modern art as a *cycle*, he nevertheless narrated it as a *process*.[26] He uses terms for the problem and for the solution which he did not even invent himself. Art is "difficult." The problem to be solved is its "difficulty." It was successively and collectively solved, in the form of a common search for the ideal solution or "perfection."

All artists, according to Vasari, participate in the search for the "end and the perfection of art" ("il fine e la per-fezione dell'arte").[27] "The difficulty of the so beautiful, dif-ficult, and glorious art" ("la difficultà di sì belle, difficili, ed onoratissime arti") is the object and at the same time the impulse of progress.[28] Michelangelo and his contempo-raries "tore off the veil of difficulties" from that which could be conceived and accomplished in the arts.[29] Others contributed nothing to this enterprise: for example Boc-caccino, whom Vasari charged with having lived fifty-eight years without ever having done anything for the improve-

ment of art.[30] But the process was inexorable in its movement toward the fulfillment of the norm; it achieved itself autonomously, almost beyond the control of the individual participants. The art of painting is "today so perfect and easy for those who have mastered 'disegno,' 'invenzione,' and color, that while in earlier days our masters painted *one* panel in six years, today they paint *six* panels in one year."[31] Michelangelo "conquered" even those who had already "conquered" nature: the masters of antiquity.[32]

Nature and antiquity were the twin ideal types, the keys to the solution of the problem and at the same time the goals of progress. Thus the entrance into the third or modern epoch is brought into causal connection with the contemporary discovery of antique statues, that is, the very exemplars of that canon which seemed to have prototypically "conquered" nature.[33]

Coming from Vasari, a disciple of Michelangelo, this observation carries a special meaning. The vehicle of the principle and also the development of art is "disegno." This is above all the outline drawing of the nude body as the proper natural form to be reproduced, for which the antique statues served as apprentice pieces. "Disegno" is then the visual expression par excellence of the "concetto" or the "idea" of art, in which the most perfect natural forms were filtered into consummate artistic form. This artistic form, as Svetlana Alpers has shown, was considered the essential vehicle of stylistic development. But as a *means* of representation which could be improved, "disegno" was to be distinguished from the permanent *task* or problem of representation, which lay in "invenzione," or the appropriate composition of a theme.[34] This distinction between "disegno" and "invenzione" suggests for the first time the possibility of seeing the work of art as both incomplete within history, and complete in terms of a perfection available to any work.

Vasari and His Legacy

4

Two questions now call for answers: Had the understanding of art history which Vasari shared already been in any sense shaping and propelling artistic activity itself? And further: How did the development of art come to be conceived as a solution to problems not in the sense of a manual craft but rather in a conceptual sense, as the development of a universal rule of beauty?

The first question can be affirmatively answered. Leonardo's writings are an important source. According to Leonardo, if the artist is to succeed in "representing foreshortening, relief, and movement, which are the glory of painting," he ought to listen not to his clients but rather to the criticism of the best artists.[35] The anecdote about Uccello losing sleep over the riddles of perspective is well known. It recalls our attention to the humanistic circles of early quattrocento Florence, where linear perspective was invented and indeed where the course was set for the entire subsequent development of art. The *Commentarii* of Ghiberti are the most important direct testimony of an artist from this time.[36] They belong to Vasari's sources.[37] Ghiberti held up the representation of reality in art as a value in itself. He commented on Pliny's account of the competition between Apelles and Protogenes as a "demonstration" of the solution of a problem, a demonstration which he thought must have impressed "painters, sculptors, and other experts."[38] Filippo Brunelleschi's lost perspectival representations of the Baptistry, which demonstrated the "costruzione legittima" of the *picture* space as a *viewing* space, were lessons in applied geometry. Leon Battista Alberti and Brunelleschi's biographer called them "dimostrazione" or exercises, solutions for problems which could be demonstrated and learned.[39] The knowledge they imparted was more than a technique of painting:

it was a theoretically grounded "science." Accordingly, painting came to share in an idea of progress peculiar to science. It became, as Arnold Gehlen points out, "an approach to the world closely associated" with that of the sciences.[40] And at the same time the ideal type of a science was to be found above all "in the guise of an aesthetic doctrine."[41]

With this we are able to answer the second question, about the sources of Vasari's concept of development. Technique is no longer merely handicraft, but rather a science of the reproduction of nature capable of independent development. Although this science did not remain limited to the problem of perspective, it did find here its first paradigm. And this new paradigm transformed artistic production. It was, however, itself the product of a process which, as even Vasari recognized, had begun much earlier. For the art production of the Renaissance was rooted in a craft whose professional mastery involved both continuity and progress at the same time.[42] The craft handed down a mastery of tools and materials and the technique of the reproduction of nature—a learnable body of knowledge long protected by guild regulations. The difference between the visual arts, as an erstwhile "ars mechanica," and literature is obvious. The guild was more closed to progress than open; indeed, progress was manipulated as a guild secret. Thus the significance of art's revaluation as a science in which all may participate, a science written about no longer exclusively for internal consumption but for the general public as well. The revaluation occurred suddenly but had been prepared long beforehand, indeed, ever since the time of Giotto. We might at least mention some of the transformations in the actual procedures of artistic creation.

The significance of the concept of "disegno" in aesthetic theory is grounded in the gradual emergence of the "disegnamento" or sketch in artistic practice. Robert Oertel has written the fundamental study of this phenomenon.[43] The

Vasari and His Legacy

sketch was exalted and isolated as the vehicle for the essential idea of a work. Even the buying public came to honor the sketch as an independent product, eventually to consider it the essential product. Indeed, in extreme cases the finished work of art was degraded to the status of a mere execution or "application" of the sketch. It remains to be seen whether in fact "Florence alone was capable of this abstraction, of making 'disegno' the vehicle of creative forces."[44] Still, Oertel succeeded in drawing attention to Florence as a social and cultural milieu; and in fact the process just described was native to or at least centered in Florence.

Florence suddenly emerges as a panorama of interactions no longer adequately accounted for by the traditional local witnesses. We can only offer the briefest suggestions in the way of explanation. Among the long-term conditions which contributed to this process were surely economic stability, social mobility, and political continuity. It is also worth mentioning such special factors as the role played in Florence by the Medici, despite all vicissitudes so tenacious; or the dialectical relationship between the city's strong sense of local identity and its active exchange with the outside world through trade. Expansion and social mobility fostered a progress-minded optimism which despite crises always managed to regenerate itself. In this climate art could contribute to the cultural self-definition of the young city state. Tradition had to be created, indeed invented: for the citizens of a republic, renaissance meant laying claim to antique precedents. In this sense, too, we can speak of an incubation period of the Renaissance.[45]

The celebrated social rise of the Renaissance artist took place on the public stage of civic life. Artistic achievement came to be rewarded with prestige and social standing, especially when this achievement was acknowledged as a contribution to the community. This community or public, because it was limited and structured, was comprehensi-

ble to its every member. The individual found his place within the society and entered into competition with others; he could exercise direct influence on the course of events. Here emerged that consciousness of the "unity of the problem" in the development of a new art. But at a certain level the competition was no longer governed by the market mechanisms which had so unsettled the medieval commission-based production. The transformation of art into the vehicle for a self-regulating discovery of reality and ideal beauty created, in the drive to perfection, new valuations on the market. Artistic quality, when its criteria came to be discussed beyong the market, constituted itself as a quasi-sacral value. In the long run the function of art became precisely its accepted lack of function, its aesthetic autonomy.[46] The social rise of the craftsman to the "priest of art" constitutes a special strand of the story, indeed, one that markedly resembles a process. The "Platonic academy" provided philosophical justifications for the new role of the artist: the notion of the inspiration of the artist found its first expression in the circle of Marsilio Ficino.[47] But in this respect Vasari himself was to have the last word, with the founding of the Florentine Academy. Already in his *Lives* he had celebrated Raphael as the archetype among artists of the "gentiluomo."[48]

5

This rapid glance at the stage upon which Vasari's process actually unfolded will have to suffice. At the very least we may have warded off the misunderstanding that humanist doctrine itself set the artistic process in motion, as well as the other possible misunderstanding that it only *invented* this process. Its contribution consisted rather in providing, through its commentary on the course of events and in its reference back to analogies in antiquity, a model of understanding and a new conceptual vocabulary.[49] In this respect it did indeed generate its own peculiar impulses, for

Vasari and His Legacy

it suggested that a new epoch had begun and was proceed-
ing toward a great future, a future of antique proportions.
Even in artists' circles, as the case of Ghiberti demon-
strates, such a doctrine could arouse or legitimate a new
self-understanding.

The acceptance of this self-understanding beyond Flor-
ence is a fascinating process in itself. Sometimes the expor-
tation of artistic norms to other schools engendered more
difficulties than it solved. For the artist north of the Alps,
the journey to Italy became a voyage of discovery into the
homeland of art. Albrecht Dürer, who was among the ear-
liest of these pilgrims, expressed his own consciousness of
a paradigmatic process of renewal thus: "Art only began to
develop anew a century and a half ago. And I hope it shall
grow further and bear its fruit, and especially in Italy, after
which it may come to us."[50] Here is the essence of Vasari's
view of history *avant la lettre*—and at that, formulated by
an outsider.

Regardless of how the process described by Vasari is
analyzed, surely enough of its aspects have been assembled
to justify the claim that it was a real process. Its achieve-
ments, after all, were endorsed well beyond the borders of
Florence. It consisted not only of a new physiognomy of
art, but also of a theory of normative laws which had been
historically "discovered." Art and the theory of art had
fallen into a reciprocal relationship which could never
again be resolved into its original components of mere
praxis and mere theory.

6

Vasari was convinced that the development toward the
classical norm had already attained its goal. A degree of
saturation appeared to have been reached which placed
progress itself in question, even in jeopardy. For Vasari, art
had attained what it was to have attained and what it was
capable of attaining, according to the established criteria;

a continuation along the same route was no longer conceivable other than as loss or decadence.[51] We might well choose to understand the phenomenon known as mannerism as a crisis of the aesthetic doctrine which Vasari had adopted.[52] Although this crisis for a long time found no adequate literary expression, it was nevertheless revealed in certain attributes of the works of art themselves, particularly when the "intellectual mastery" and technical reproduction of nature were no longer valued in themselves but were instead replaced by a self-reproducing art form or by the tension between a spiritual "invenzione" and the natural form.

But let us return to Vasari. Vasari's awareness that the process was finished and the norms fulfilled had specific practical consequences. After all, he had a historical role of his own. Among these consequences was the *Lives* itself, which formulates and codifies an aesthetic canon. The collection of *exempla,* of artists' lives, presents this canon both directly, in the normative aesthetic doctrine, and indirectly, in the narration of the historical course of "education" toward the norms, from which one is supposed to learn the "lesson of history." Artists themselves are responsible if the norms fall again into oblivion, just as they were once responsible for rescuing them from oblivion. Vasari's work is a history of artists for artists. It constructs a history of art in which only the artists figure. It is precisely in its rather one-sided view of a simple immanent development of art, in its antiquated conception of an event orchestrated by the actors themselves, that Vasari's work reveals itself most clearly as a document of its time.

Once again a dialectical relationship ensues between that which Vasari merely thinks and describes, and the reality which he bears witness to through description. The very conviction that the cycle is complete is itself a symptom of the completeness of the cycle. The procedure of collecting and taking stock characterizes a late phase of a

cultural cycle. Historical interest then takes on defensive traits. In antiquity, too, collecting and codification in art historiography coincided with the development of a retrospective art and the recognition of absolute models and precedents. In the East, the *Painter's Manual* of Mount Athos with its iconographic rules appeared only in post-Byzantine times.

The same attitude which produced the *Lives* also accounts for the establishment of the first academy of art; indeed, its spiritual father was Vasari himself.[53] In the academy aesthetic doctrine was institutionalized, and not only as lessons for those studying there, but in a collection of examples, which according to the original scheme was to consist of an ideal collection of historical works of art. The individual works were to be in the Academy what the individual biographies were in the *Lives*. The ideal—in practice unrealizable—was a collection comprising the very works described in the *Lives*. The plan was carried out only in Vasari's so-called *Libro*, an album of original drawings by the artists of the *Lives*.[54] It was organized along historical lines and at first even embellished with historicizing frames, which were to express appropriately the chronological sequence of the drawings.[55] And written on each passe-partout, as in future print cabinets, was the exact art-historical allocation.

The Accademia del Disegno was founded in Florence in 1563, chronologically between the two editions of the *Lives*. The *Lives* had erected as absolute standards the "maniere" of the Golden Age of art, specifically those of the troika of Leonardo, Raphael, and Michelangelo; the Academy in turn proposed a theoretical and practical education according to the ideals of style of the *Lives*. In effect the program promoted both the preservation of historical monuments and education. The analogy between the purposes of the *Lives* and of the founding of the institution is obvious. The statutes of the Academy called for a frieze with the portraits of

the members and their illustrious predecessors, a kind of Pantheon of Florentine artists.[56] Accordingly, the second edition of the *Lives* offered woodcut portraits of all 250 artists, based if possible on authentic historical models. Still more important was the provision in the Academy's charter for a library in which the necessary models, in the form of drawings of and designs for works of art, were to be preserved as study material "for youth, for the purpose of preserving these arts." The "application" of art-historical writing in the institutions of the museum and the academy appears here in its prototypical form.

The two and a half centuries between the foundation of the first academy and the secession of the later Nazarenes from the Viennese Academy might even be thought of as the age of academies. Academies became the temples of the aesthetic doctrine which Vasari had hoped to erect for all times on the basis of the norms of his own time. They mark as well the age of Vasari's uncontested authority. The numerous imitations of or sequels to his *Lives* in the ensuing age perpetuated his historiographical model and extended it beyond the borders of Italy.[57] We need only mention Karel van Mander's *Schilderboek* of 1604 or Joachim von Sandrart's *Teutsche Akademie* of 1675. From mere collections of facts to plagiarisms to independent adoptions of Vasari's historical model, nearly all possible variations were represented in this post-Vasarian corpus.

Yet one problem never disappeared: the problem of how to write the subsequent history of something which had already appeared in Vasari's "bible" as a finished process. The twin standards of Greek and Florentine classicisms tended to discourage further work. A historical theory of Baroque art, properly speaking, never emerged at all, certainly not of the scope of Vasari's project. Writing on art listed sharply toward a very partial classicism, toward strict selection from and even conscious or unconscious estrangement from contemporary art. Art thus became a

chain of rebirths perpetually denying the decay of the classical. The inflation of regenerations necessarily weakened the historical meaning of regeneration: it hardly masked the essentially stationary character of this historical process. For Vasari's *Lives* provided less a model of art-historical writing than a set of aesthetic norms. And these same norms still served Winckelmann in his polemic against the art of *his* time.

7

It would be worthwhile to compare Vasari and Winckelmann. At first glance, to be sure, the differences so dominate that even the suggestion of their similarity seems unwarranted. Winckelmann's enterprise is new in that it does not describe the art of its own time but rather that of antiquity.[58] It is also new in that it presents not biographies of artists but a "history of art." Yet the first part of this history, especially in the chapter on the rise and fall of Greek art, presents a theory of style which is in effect a remarkable reworking of that which Vasari, also on the basis of antique sources, had already attempted within a simpler framework. The second part describes art under its historical conditions, for art according to Winckelmann "is dependent on its historical epoch and historical change."[59] This assignment of art to the domain of general history not only implies that art requires favorable opportunities and deliberate encouragement, indeed, moral as much as material encouragement. It also suggests a parallel between political freedom and the flowering of art. "It becomes clear through this entire history that it was freedom which promoted art."[60] Freedom does not mean freedom of art, which is on the contrary bound to norms, but rather man's free development toward his natural capabilities. The relevance to contemporary art and society of such a historical vision is obvious. Winckelmann's synopsis of history and the history of art, however, consists of nothing more than a simple re-

telling of the instructive course of history: the potentially current themes of organic growth and the natural forces of the people remain dormant, except perhaps in the hypothesis of the Greeks' natural inclination to art.

A true picture of art history does reveal itself, however, in the "inner history" of art, which Winckelmann—true to the post-Vasarian tradition—describes through the metaphor of organic growth. Art is numbered among the "operations of nature"; thus the devolution from the classical, where the forms of beauty had been elaborated to the point of exhaustion, to decadence, is seen as inevitable: "Art, which like any operation of nature could not possibly settle at a fixed point, had to diminish," and so "was opened the way to imitation."[61] Already Vasari had warned against blind imitation of Michelangelo. For Winckelmann, who looked back over two further centuries of art production, uncreative imitation in art had become a phenomenon of such significance that he even attached the term to a particular antique style.[62]

I do not wish to reduce the work of Winckelmann to that of Vasari; and yet the norms of Vasari's aesthetic doctrine, which themselves stand on an antique footing, are omnipresent. They furnish not only terminology and the criteria of representation, but also provide the art critic Winckelmann with an orientation. In pointing out that "drawing from the nude" discloses the "truth and beauty of form," Winckelmann pays homage to Vasari's old "disegno."[63] "The source and the origin of art is nature";[64] but then the body of the Torso Belvedere is "elevated beyond nature,"[65] and the Apollo Belvedere is "constructed entirely according to the ideal."[66] We recognize Vasari's ambivalent conception of nature, even if here it is dissociated from the "didactic edifice" of rules—with which phrase Winckelmann castigates the academies of his own day. The ideal types of antiquity and nature remain unchallenged. For example, Winckelmann still condemns artists such as Ber-

nini with the lapidary verdict: "They forsake nature and antiquity."[67]

Winckelmann's puritanical classicism is at the same time symptomatic of a crisis in post-Vasarian art-historical writing. Winckelmann is clearly uneasy about commenting on art produced since Vasari. Neglect of contemporary art, like fascination with the art of a lost antiquity, was one of the possible consequences of the awareness of Florentine classicism and its claimed monopoly on the legacy of antique classicism. The antique version had become so to speak the original, the Florentine version its reincarnation—although of course it could never quite match the original. Winckelmann breaks with the monopoly of the Florentine heritage not through an *artistic*, but rather a *historical* adoption of antiquity. From a standpoint of disinterested contemplation he seeks the "true" antiquity, in which he discovers its "true" artistic documents and interprets them "according to their art."[68] But the Winckelmann who detaches art history from art[69] or who in his historical work provides the "surrogate" of a no longer available art,[70] is not the whole Winckelmann. He is equally the friend of the painter Anton Raphael Mengs, that "German Raphael" and "re-establisher of art," who "arose as it were like a phoenix from the ashes of the first Raphael, in order by his art to instruct the world in beauty." In Mengs's works Winckelmann finds "the quintessence of all the beauty described in the figures of the ancients."[71] Here speaks the spiritual father of the last truly international artistic style. Again he seems to follow in Vasari's steps: for example when he writes, with a view toward this future neoclassicism, that he wishes to convey through Greek art—the "most worthy subject to behold and imitate"—not only "knowledge, but also lessons for practical use."[72] The words could have been Vasari's; yet in the polemical context in which they were written they carried a rather different meaning: they implied not the

preservation but on the contrary the radical transformation of contemporary art.

8

Vasari's reception in the romantic era is a topic in its own right. To be sure, the *Lives* was eventually reduced to a useful anthology of source material.[73] The critical study of primary sources had been one of the first projects of the young discipline of art history. But in the meantime several new approaches to Vasari were tested. Vasari's authority was even mobilized against his own theses: Vasari refuted by Vasari, so to speak. Vasari's assertion that the Gothic was a German import, for example, entitled the Germans to claim it as a national art.[74] Of course medieval art was as remote as Winckelmann's Greek art, and the two were often played off against each other. But like Winckelmann's antiquity, the Gothic became a source of renewal for contemporary art. It offered the image of an art inspired by natural feeling and "unspoiled" by rules. Thus, under a complete reversal of circumstances, Vasari's model was in a sense reactivated.

A striking example of this continuing obligation to Vasari—coupled with the effort to be freed from him—are the *Views on the Visual Arts and the Description of Their Course in Tuscany*, published anonymously "by a German artist in Rome" in 1820. Its author was the painter Johann David Passavant, later curator of the Städel in Frankfurt. Already the choice of subject matter is significant. The "general presentation of the course of the visual arts from their rise to their fall" is undertaken on the example of Tuscany because "art in this land was most excellently developed and through the splendid work of Vasari . . . is also the most generally known."[75] The historical presentation is once again designed for practical application: to this end Passavant hopes to draw "lessons from history." The art handed down to us is the mirror of a people's greatness in history.

"History is the Last Judgment, and one knows the tree by its fruit."[76] The fruits are the works of art. They bear witness to the greatness of the German people in the Middle Ages and ought then to provide artistic norms for the renewal of this greatness. Thus is conceived the medieval renaissance.

But because Passavant remains true to Vasari's larger schema, he must in order to achieve his own ends rearm it conceptually. Hence Passavant rejects the catchall notion of "Gothic" which Vasari had applied to everything before the initiation of the modern cycle. The architectural style of the Goths he now calls pre-Gothic and Byzantine, the style of the Hohenstaufen dynasty—when Germany had attained political hegemony—German. Passavant's struggle with terms is striking, just as is his effort to associate them with real historical phenomena. For example, Passavant endorses Vasari's negative judgment of Gothic buildings in Italy. But his explanation for their deficiencies is quite unexpected: the Italians "were not properly instructed in the principles of our architecture."[77] Equally surprising is Passavant's argument that the Renaissance and its renewed interest in antiquity only became necessary after the Gothic had run out its cycle, had begun "to flag."[78] The cycles shift and multiply; antiquity becomes a mere alternative to Gothic. For the first time, the idea of the history of art as a continuous, seamless process enters into view.

But the new appreciation of the Gothic entailed a corresponding refutation of Vasari's norms. Even antiquity was no longer to be imitated in the letter but rather in the spirit. A newly defined nature is called in as a witness, in place of the old, merely imaginary rules. It was more difficult to carry over the proof into the pictorial arts. Whereas in architecture Passavant shifted what had been the prehistory of Vasari's cycle to the very center of the cycle, in the other arts he could defeat Vasari only on his own ground, in a history of the Renaissance. To begin with he evaluates the

three epochs of sculpture differently from Vasari. Already in the second epoch "the level of perfection" was reached. The artists "had not yet forsaken the great purpose of a living art," namely, to depict religious and patriotic themes. They were unconcerned to "prove themselves learned in drawing from the nude," and in the choice of subject matter had not yet fallen into an "unconditioned imitation of the antique . . . but rather remained popular."[79] The new system of values altered the meaning of the entire course of events. Progress toward the norm of antiquity is discarded as a model for the process, because "a living art [does not] follow in the tracks of an art already complete and available," but rather will "only develop in its own way."[80] In painting, Giotto has probably never "been surpassed in grandeur and truth of the idea," even if he did "concern himself less" about the means of representation.[81] "Disegno" degenerates to "illusionistic effects and correct drawing," no longer suitable as a standard for art.[82] "Invenzione" on the other hand, as the "clear presentation of a composed thought or an action," is to be valued more highly.[83] At this point Passavant turns Vasari's own weapons against Vasari.

Yet the model could not arbitrarily be invested with new content. One weakness of the new presentation lies in the difficulty of explaining the third epoch, which the author no longer wishes to erect as an absolute, but at the same time does not dare to set aside altogether. The classical triad among High Renaissance painters is only accepted with hesitation, and on quite new grounds: namely, on account of their roots in the teachings of their predecessors, whose best ideas they had supposedly combined with the best forms of nature. They had not yet degenerated to producing art as an end in itself, art whose subject matter was only a pretext for the "external" form.[84] The judgment against the subsequent age is all the more devastating. The

notion of the corruption of the good style "to a certain manner" already intimates the thesis of mannerism.[85]

It is clear that we learn more here about Passavant the Nazarene than about the Renaissance which he wanted to reinterpret. It is also evident that the structure of Vasari's model cannot be significantly altered without sacrificing the model itself. All the more meaningful, then, is the fact that the model, despite all attacks, contradictions, and revisions, has to the present day preserved a certain fascination, even if unspoken. The connection between the description of the process (the genesis of a classic art of the Renaissance) and the process itself is all the more intimate since Vasari was a first-hand witness, or at least a witness of contemporary accounts of the event. Vasari was in the position, through the accident of his biographical and historical circumstances, to bestow the highest judgments of value on precisely those artists who have enjoyed ever since, unchallenged, the highest rankings. And this is perhaps despite rather than because of Vasari, whose judgments we reluctantly acknowledge long after the dust has settled on their original rationales.

9

"Vasari and his legacy" is a theme justifiably concluded with Passavant, one of the last representatives of an active reception of Vasari's norms. His value as a source lies more in what he claims than in what he proves. On the other hand, Passavant was to participate later on in the development of a modern scholarly practice of art history. The overcoming of art historiography as applied art criticism was purchased only at great cost. Whereas earlier one had oriented oneself by the criteria of an aesthetic doctrine, one now looked to models of history borrowed from historical scholarship.

The new discipline of "objective" or scholarly writing

on art history had to construct a new framework to describe the course of art *in* history, even to establish this course as the true history it was concerned with. It never did find any lasting solutions to this self-imposed problem. The relationship between art and history is still today as unexplained as it is undisputed. Obviously any work of art is the historical product of historical men, and as such fulfilled a function and bore a message which can in principle be recovered. Just as obviously the work of art is in its *form* capable of transcending its historicity. It is this very form which is as much conditioned by historical forces as it conditions in its turn other forms to come. Here, if anywhere, appears a visible pattern of historical change in art. To be sure, the very substance of this changing artistic form—conveyed through vision—is not as factual and therefore not as open to historical treatment as subject matter, technique, and other attributes of the work of art.

What can we then conclude about form as *historical* form, that is, form as a historical source, bearing witness to history and itself standing within a history of forms? I wish to close with several provisional remarks on this general question. Again we proceed from Vasari. Vasari describes the emergence of Renaissance art as a collective and orderly forward progress toward fulfillment of certain norms immanent in nature and antiquity. Inasmuch as he sees the norms as objectively given, he relies essentially on the principles of an aesthetic doctrine which he only applies and gives form to. Inasmuch, however, as he sees the route toward fulfillment of these norms as a chain of logically consequent solutions to problems, he reveals a quite different understanding of artistic activity, one whose premises we have in fact already sketched out. The problem posed is the norm, or rather how to fulfill the norm.

But who determines this norm? Vasari's answer does not help us. It obscures the insight that the norm, in tandem with the development of art, is itself constantly changing.

Masaccio's norm was not the same as Raphael's, for it was never an absolute norm but rather always that goal recognizable as the next goal or next problem after the problem of the moment had been solved. Vasari himself speaks of technical inventions which facilitate or improve the reproduction of nature. The inventions were deposited and displayed in works of art; these solutions in turn posed new problems and rendered old ones superfluous. The norm is therefore itself incorporated into the momentum of the process: it is no longer the goal of the process, the fixed point at which all movement ceases. Only in retrospect does the distance between, say, the art of the quattrocento and the antique models at any point along the development seem measurable. At the time, of course, antique models were being interpreted and adopted in constantly varying ways. And even Vasari was aware of the role of accidents, such as the discovery of unknown antiquities.

Granted, the description of the development as a series of contiguous solutions to problems leaves unanswered the questions of the logical consistency of the process, or of its possible conclusion. We have spoken of the "saturation" in the fulfillment of norms which Vasari had imagined. His conviction that art has achieved its goal represents more than a mere epigonic instinct: it is characteristic of Vasari's own standpoint at the end of a long process. The cross-check is provided by scholarship's perception of a fundamental divide between the High Renaissance and the subsequent development, a discontinuity acknowledged even by those uncomfortable with the term mannerism. The division is necessary because one cannot measure both phenomena by the same criteria. Mannerism is certainly not to be evaluated with the criterion of the appropriation of nature, for this was a problem which no longer promised new solutions under the conditions then at hand.

Clearly there are art-historical sequences which unfold within "the unity of a problem." They eventually arrive at

a stage where the problem changes, where the successively developed solutions may themselves pose new problems. One sequence turns abruptly into another. If, despite René Wellek's warning "that a history of aesthetic products is grasped neither with categories of causality nor with those of evolution,"[86] we do choose to investigate time structures in the history of the visual arts and thus bring the conception of process into play, we must abandon the notion of a single, unidirectional process. Instead there are only several very different processes, which are constantly shifting directions and superseding one another, and yet, in their inner sequences as well as in the succession of processes, still manage to achieve a certain consequentiality. This consequentiality is never fixed as a program from the start, for countless external factors are continually acting upon the duration, length, tempo, and direction of the process. We have arrived at the threshold of an anthropologically grounded conception of artistic production as a paradigm of human activity, a possibility which was most recently explored, in a general theory of the historicity of art and its products, by George Kubler.[87]

Vasari and His Legacy

Notes

Preface

1. Hans Belting, "La fin d'une tradition?" *Revue de l'art* 69 (1985):4ff.
2. Hans Belting, *Max Beckmann: Die Tradition als Problem in der Kunst der Moderne* (Munich: Deutscher Kunstverlag, 1984).

One: The End of the History of Art?

1. Hervé Fischer, *L'histoire de l'art est terminée* (Paris: Balland, 1981), 78.
2. Ibid., 106.
3. Dieter Henrich and Wolfgang Iser, eds., *Theorien der Kunst* (Frankfurt: Suhrkamp, 1982).
4. Giorgio Vasari, *Le vite de' più eccellenti pittori, scultori ed architettori scritte da Giorgio Vasari pittore Aretino*, ed. Gaetano Milanesi (Florence: Sansoni, 1906 [after the edition of 1568]); available in various English translations. See also T. S. R. Boase, *Giorgio Vasari: The Man and the Book* (Princeton, N.J.: Princeton University Press, 1971); and Hans Belting, "Vasari und die Folgen: Die Geschichte der Kunst als Prozess?" in ed. Karl-Georg Faber and Christian Meier, *Theorie der Geschichte 2: Historische Prozesse* (Munich: Deutscher Taschenbuch Verlag, 1978); translated below, pp. 67–94.
5. Heinrich Dilly, in *Kunstgeschichte als Institution* (Frankfurt: Suhrkamp, 1979), offers an excellent analysis of the early history of the discipline and reconstructs its various shaping factors, most of which we are not able to discuss in any greater detail here.
6. Jochen Schlobach, "Die klassisch-humanistische Zyklentheorie und ihre Anfechtung durch das Fortschrittsbewusstsein der französischen Frühaufklärung," in *Theorie der Geschichte 2*, 127ff.
7. Johann Joachim Winckelmann, *Geschichte der Kunst des Altertums* (Dresden, 1764; Darmstadt: Wissenschaftliche Buchgesellschaft, 1972); trans. G. Henry Lodge as *The History of Ancient Art*, various eds. See Carl Justi, *Winckelmann und seine Zeitgenossen* (Leipzig, 1898); Wolfgang Leppmann, *Winckelmann* (New York: Knopf, 1970); Herbert Beck and Peter C. Bol, eds., *Forschungen zur Villa Albani: Antike Kunst und die Epoche der Aufklärung* (Berlin:

Mann, 1982); and Dilly, *Kunstgeschichte als Institution,* 90ff.

8. See below, pp. 85–88.

9. Hans Robert Jauss, *Literaturgeschichte als Provokation* (Frankfurt: Suhrkamp, 1970), 153ff. Translated in Jauss, *Toward an Aesthetic of Reception,* trans. Timothy Bahti (Minneapolis: University of Minnesota Press, 1982).

10. Georg Wilhelm Friedrich Hegel, *Vorlesungen über die Ästhetik,* ed. H. G. Botho (Berlin, 1835, 1842, 1953). Translated as *Aesthetics: Lectures on Fine Art* by T. M. Knox (Oxford University Press, 1975). See also the *Theorie-Werkausgabe* of Eva Moldenhauer and Karl Markus Michel (Frankfurt: Suhrkamp, 1969–). For the literature, see Wolfhart Henckmann, "Bibliographie zur Ästhetik Hegels," in *Hegel-Studien* (Bonn, 1969), 5:379ff.; *Hegel-Jahrbücher* 1964–66; Werner Koepsel, *Die Rezeption der Hegelschen Ästhetik im 20. Jahrhundert* (Bonn: Bouvier, 1975); and Jeannot Simmen, *Kunst-Ideal oder Augenschein: Systematik, Sprache, Malerei: ein Versuch zu Hegels Ästhetik* (Berlin: Medusa, 1980). See Theodor W. Adorno, *Ästhetische Theorie,* Gesammelte Schriften, vol. 7 (Frankfurt: Suhrkamp, 1970), 309–10; translated as *Aesthetic Theory* (London, Boston: Routledge and Kegan Paul, 1984), 296–98, on the contradiction between art as a manifestation of truth and as the conservator of an antique canon. Adorno's understanding and critique of Hegel cannot, however, be examined any more closely here. For a historical evaluation of Hegel's aesthetics, see above all the article "Ästhetik" by Joachim Ritter in *Historisches Wörterbuch der Philosophie* (Basel: Schwabe, 1971), 1:555ff. and especially 570ff. On Hegel's significance today, see Dieter Henrich, "Kunst und Philosophie der Gegenwart (Überlegungen mit Rücksicht auf Hegel)," in *Immanente Ästhetik, Ästhetische Reflexion,* ed. Wolfgang Iser, Poetik und Hermeneutik 2 (Munich: Fink, 1966), 11ff.

11. Hegel, *Ästhetik,* 1:32; *Aesthetics,* 1:11. (Subsequent references will list the German edition first, then the English translation.) The work of art provides not only "enjoyment" but also the possibility of our "judgment," namely, upon the relationship between "content" and "means of representation." "The *philosophy* of art is there-

fore a greater need in our own day than it was in days when art by itself as art yielded full satisfaction."

12. Ibid., 2:231; 1:604.

13. Ibid., 2:231ff.; 1:604ff.

14. Ibid., 2:224–25; 2:614: "Each art has its time of efflorescence, of its perfect development as art, and a history preceding and following this moment of perfection." Its products, as "works of the spirit" and therefore unlike the products of nature, are not "complete all at once;" rather they show an orderly course of development from "beginnings" to "endings." See also ibid., 2:3; 1:427: "The centre of art is a unification, self-enclosed so as to be a free totality, a unification of the content with its entirely adequate shape. . . . The Ideal provides the content and form of classical art which . . . achieves what true art is in its essential nature." The harmony of individual and community, of subjectivity and collective normative values, is understood as a condition for the classic beauty achieved by the Greeks (ibid., 2:16; 1:436ff.).

15. Benedetto Croce, *Ciò che è vivo e ciò che è morto della filosofia di Hegel; studio critico* (Bari: Laterza, 1907). Translated as *What Is Living and What Is Dead of the Philosophy of Hegel* (London: Macmillan, 1915). See also Croce, "La 'fine dell'arte' nel sistema hegeliano" (1933), in *Ultimi saggi* (Bari: Laterza, 1948), 147ff.

16. Hegel, *Ästhetik*, 1:32; *Aesthetics*, 1:11.

17. Ibid., 2:143; 1:535.

18. Ibid., 1:151; 1:151.

19. On the "perpetuation" of Hegelian ideas into modernism, see Henrich, "Kunst und Philosophie der Gegenwart."

20. Ritter, "Ästhetik," 560.

21. Hegel, *Ästhetik*, 1:38ff.; *Aesthetics*, 1:14ff.

22. Ritter, "Ästhetik," 576.

23. Cf. Wolfgang Kemp, *John Ruskin* (Munich: Hanser, 1983).

24. Horst W. Janson, "The Myth of the Avant-Garde," in *Art Studies for an Editor: Twenty-five Essays in Memory of Milton S. Fox* (New York: Abrams, 1975), 168ff.

25. Donald Drew Egbert, "The Idea of 'Avant-garde' in Art and Politics," *The American Historical Review* 73

(1967):339ff. On this topic see *Avantgarde, Geschichte und Krise einer Idee* (Munich: Bayerische Akademie der Schönen Künste, 1966); Thomas B. Hess and John Ashbery, eds., "The Avant-Garde," *Art News Annual* 34 (1968); Peter Bürger, *Theorie der Avantgarde* (Frankfurt: Suhrkamp, 1974), translated as *Theory of the Avant-Garde*, Theory and History of Literature, 4 (Minneapolis: University of Minnesota Press, 1984); Winfried Wehle, "Avantgarde: ein historisch-systemat. Paradigma 'moderner' Literatur und Kunst," in *Lyrik und Malerei der Avantgarde*, ed. Rainer Warning and Winfried Wehle (Munich: Fink, 1982), 9ff., with a useful inventory of the most important theories and problems of the avant-garde. Harold Rosenberg has offered the most acute analyses of the crisis of the avant-garde in the visual arts, especially in his collections of essays *The De-Definition of Art* (New York: Horizon, 1972) (see 212ff.: "D.M.Z. Vanguardism") and *The Anxious Object* (New York: Horizon, 1964) (see 25ff.: "Past and Possibility"). Renato Poggioli's posthumous *Theory of the Avant-Garde* (Cambridge, Mass.: Harvard University Press, 1968) is an apology for the avant-garde, arguing that the avant-garde must endure as long as the artist remains alienated from the society. For a critique of this thesis see Rosenberg, *The De-Definition of Art*, 216ff.

26. Willibald Sauerländer, "Alois Riegl und die Entstehung der autonomen Kunstgeschichte," in *Fin de Siècle: Zu Literatur und Kunst der Jahrhundertwende* (Frankfurt: Klostermann, 1977), 125ff.

27. Cf. Werner Hofmann, "Anstelle eines Nachrufs," *Idea* 3 (Hamburg, 1984), 7ff.

28. Werner Weisbach, *Impressionismus: Ein Problem der Malerei in der Antike und Neuzeit* (Berlin, 1911).

29. On the contemporary crisis of avant-gardism, see Christopher Finch, "On the Absence of an Avant-garde," *Art International* 10, no. 10 (December 1966):22–23; Rosenberg, *The De-Definition of Art*, 212ff.; the contributions by Ihab Hassan, Miklos Szabolcsi, and others on the avant-garde, modernism, and postmodernism, *New Literary History* 3 (1972), passim; Eduard Beaucamp, *Das Dilemma der Avantgarde* (Frankfurt: Suhrkamp, 1976), esp. 180ff. and 257ff.; Beaucamp, "Ende der Avantgarde—was nun?" *Das Kunstjahrbuch* 1977/78, ed. Horst Richter, 24ff.; Thomas

W. Gaethgens, "Wo ist die Avantgarde?" *Kunstchronik* 30 (1977):472ff.; Nicos Hadjinicolaou, "L'idéologie de l'avant-gardisme," *Histoire et critique des arts* 6 (July 1978):49ff.; "Fine delle Avanguardie?" *Ulisse*, anno XXXII.14 (Florence, 1978); Bazon Brock, "Avantgarde und Mythos," and Klaus Honnef, "Abschied von der Avantgarde," *Kunstforum* 40 (1980):17ff. and 86ff.; Achille Bonito Oliva, *Tra Avanguardia e Transavanguardia* (Milan, 1981); Robert Ederer, *Die Grenzen der Kunst: Eine kritische Analyse der Moderne* (Vienna: Boehlaus, 1982).

30. Ludwig Coellen, *Der Stil in der bildenden Kunst* (Darmstadt, 1921); Heinrich Wölfflin, *Kunstgeschichtliche Grundbegriffe: Das Problem der Stilentwicklung in der neueren Kunst* (Munich, 1915); translated as *Principles of Art History: The Problem of the Development of Style in Later Art* by M. D. Hottinger (London: G. Bell, 1932; New York: Dover, 1950). Wölfflin explains in the foreword to the 1915 edition (p. vii; not translated): "We must at last have an art history in which the development of modern vision can be followed step by step, an art history which tells not only of individual artists, but reveals in a continuous sequence" the genesis of styles. For a discussion of the concept and its misunderstandings, see Meinhold Lurz, *Heinrich Wölfflin: Biographie einer Kunsttheorie*, Heidelberger Kunstgeschichtliche Abhandlungen, n.F., vol. 14 (Worms: Werner'sche Verlagsgesellschaft, 1981), 18ff.

The notion of the "musée imaginaire" stems from André Malraux, *Le Musée imaginaire* (1947) and forms a part of his project of a "psychology of the art" of all times and peoples, which is by no means equivalent to Wölfflin's intentions.

31. Theodor W. Adorno, *Ästhetische Theorie*, 336; *Aesthetic Theory*, 322: "If any social function can be ascribed to art at all, it is the function to have no function."

32. Alois Riegl, *Spätrömische Kunstindustrie* (1901), ed. E. Reisch (Vienna, 1927), and *Gesammelte Aufsätze*, ed. Karl M. Swoboda (Augsburg-Vienna, 1929); Erwin Panofsky, "Der Begriff des Kunstwollens," *Zeitschrift für Ästhetik und allgemeine Kunstwissenschaft* 14 (1926); Otto Pächt, *Methodisches zur kunsthistorischen Praxis* (Munich: Prestel, 1977), 141ff.; Sauerländer, "Alois Riegl"; and Ar-

tur Rosenauer in *Problemi di metodo; condizioni di esistenza di una storia dell'arte*, Atti del XXIV Congresso Internazionale di Storia dell'Arte, 1979, part 10 (Bologna, 1982), 55ff.

33. Henri Focillon, *La Vie des formes* (Paris: P.U.F., 1939), trans. Charles Beecher Hogan and George Kubler as *The Life of Forms in Art* (New Haven: Yale University Press, 1942); Kubler, *The Shape of Time: Remarks on the History of Things* (New Haven: Yale University Press, 1962). Cf. Sergiusz Michalski in *Problemi di metodo*, 69ff.

34. Siegfried Kracauer, *History, the Last Things before the Last* (New York: Oxford University Press, 1969). For Adorno's formula, see *Ästhetische Theorie*, 310–11; *Aesthetic Theory*, 299.

35. The best source is Ekkehard Kaemmerling, ed., *Bildende Kunst als Zeichensystem 1: Ikonographie und Ikonologie* (Cologne: DuMont, 1978). Most important are the works of Panofsky, e.g., "Iconography and Iconology" or "The History of Art as a Humanistic Discipline," in *Meaning in the Visual Arts* (Garden City, N.Y.: Doubleday, 1955).

36. The works of Aby M. Warburg are most accessible today in *Ausgewählte Schriften und Würdigungen*, Saecula Spiritalia, vol. 1, ed. Dieter Wuttke (Baden-Baden, 1979). Cf. also Ernst H. Gombrich, *Aby Warburg: An Intellectual Biography* (London: Warburg Institute, 1970); Edgar Wind, "Warburgs Begriff der Kulturwissenschaft" (1931), in Kaemmerling, *Bildende Kunst als Zeichensystem*, 165ff.

37. On this see Sauerländer, "Alois Riegl."

38. Hans Georg Gadamer, *Wahrheit und Methode: Grundzüge einer philosophischen Hermeneutik* (Tübingen: J. C. B. Mohr [Paul Siebeck], 1960); translated as *Truth and Method* (London: Sheed and Ward, 1975; New York: Crossroad, 1982); Gadamer, "Hermeneutik," in Ritter, ed., *Historisches Wörterbuch der Philosophie* (1973), 3:1061ff. From the start the question has been whether understanding is more "than the reproduction of the original production." The next step is "to reveal the limits of a self-generated historical knowledge" and to refer understanding back to a given (1067–68). Thus the experience of art plays a special role in Gadamer's system, a role anterior to science and its relativization.

In addition see Wilhelm Dilthey, *Gesammelte Schriften* (Stuttgart: Teubner, 1962–74), vols. 1, 5 (esp. "Die Ent-

stehung der Hermeneutik''), 7, 11 (1914–16); Edmund Husserl, *Logische Untersuchungen* I/1 (Tübingen: Niemeyer, 1968, from 2d ed. of 1913); Erich Rothacker, *Einleitung in die Geisteswissenschaften* (Tübingen: Mohr, 1920); Joachim Wach, *Das Verstehen: Grundzüge einer Geschichte der hermeneutischen Theorien des 19. Jhs.* (Tübingen: Mohr [Paul Siebeck], 1929–33); Paul Ricoeur, *The Conflict of Interpretations: Essays in Hermeneutics* (Evanston, Ill.: Northwestern University Press, 1974).

39. Gadamer, "Hermeneutik," 1070.

40. On the history of art criticism, see Lionello Venturi, *History of Art Criticism* (New York: Dutton, 1936), and Albert Dresdner, *Die Entstehung der Kunstkritik* (Munich: Bruckmann, 1915, 1968.) On the controversy surrounding contemporary criticism, see Richard Cork, *The Social Role of Art: Essays in Criticism for a Newspaper Public* (London: G. Fraser, 1979); the anthology *Art and Criticism* (Winchester School of Arts); and Sarah Kent, "Critical Issues," *Time*, 1 February 1980.

41. Dilthey, "Die Einbildungskraft des Dichters" (1887), in *Gesammelte Schriften* (1958 or 1964), 6:105. It ought to be pointed out that Dilthey is referring as well to the "thirst for reality, for scientifically fixed truth" of art itself, which is becoming "democratic."

42. Hans Sedlmayr, *Kunst and Wahrheit* (Mittenwald: Mäander, 1978), 107: this act of viewing is the very "essence of reproduction." Interpretation should "permit the concrete form of the work of art to emerge in a visible process" (from *Kritische Berichte zur kunstgeschichtlichen Literatur* 3–4 [1932], 150). Understanding is "a re-creation of *works* of art out of mere art objects." This volume also reprints crucial essays such as "Zu einer strengen Kunstwissenschaft" of 1931.

43. See note 38 above. "The productive contribution of the interpreter belongs necessarily to the meaning of the understanding itself." The distance provides "understanding with tension and life. Thus through language" the object of understanding is brought to new expression. For because our orientation to the world is "linguistically constituted," experience can only be articulated linguistically. Gadamer, "Hermeneutik," 1070ff.

44. Wölfflin, *Principles of Art History*, 227: "In its

breadth, the whole process of the transformation of the imagination has been reduced to five pairs of concepts. We can call them categories of beholding. . ." In his conclusion ("The outer and inner history of art") Wölfflin says that he did not wish to characterize the art of the sixteenth and seventeenth centuries so much as "the schema and the visual and creative possibilities within which art remained in both cases" (226). Cf. also the second, more general part of Wölfflin's earlier *Klassische Kunst* (Munich, 1898), translated as *Classic Art: An Introduction to the Italian Renaissance* (London: Phaidon, 1952; Ithaca: Cornell University Press, 1980).

45. Out of the vast literature see esp. André Malraux, *Psychologie de l'art* (Geneva: Skira, 1947–50), translated as *The Psychology of Art* (New York: Pantheon, 1949–50); Ernst Kris, *Psychoanalytic Explorations in Art* (New York: International Universities Press, 1952); Walter Winkler, *Psychologie der modernen Kunst* (Tübingen: Alma Mater Verlag, 1949); Rudolf Arnheim, *Art and Visual Perception: A Psychology of the Creative Eye* (Berkeley: University of California Press, 1954); and Richard Kuhns, "Psychoanalytische Theorie als Kunstphilosophie," in *Theorien der Kunst*, ed. Heinrich and Iser, 179ff.

46. Gombrich, *Art and Illusion: A Study in the Psychology of Pictorial Representation*, the A. W. Mellon Lectures in the Fine Arts, 1956; Bollingen Series XXXV.5 (Princeton, N.J.: Princeton University Press, 1960), esp. the introduction, as well as Gombrich, "Norm and Form: The Stylistic Categories of Art History and Their Origins in Renaissance Ideals," in *Norm and Form: Studies in the Art of the Renaissance* (London: Phaidon, 1966, 1978). In *The Sense of Order: A Study in the Psychology of Decorative Art* (Ithaca, N.Y.: Cornell University Press, 1979) Gombrich attempted to apply his psychology of style to ornament. On Gombrich, see Henrich and Iser in *Theorien der Kunst*, 20–21 and 43ff.

47. Cf. also Gombrich, "The Logic of Vanity Fair," in *The Philosophy of Karl Popper*, ed. Paul Arthur Schilpp, The Library of Living Philosophers, 14 (La Salle, Ill.: Open Court, 1974), 925ff.

48. This by no means applies exclusively to realism, which represents only a particular variant of this rela-

tionship to reality (historically the term became important in the time of Gustave Courbet and the mid-nineteenth-century debate on realism). On the term realism, see Reinhold Grimm and Jost Hermand, eds., *Realismustheorien in Literatur, Malerei, Musik und Politik* (Stuttgart: Kohlhammer, 1975) and Stephan Kohl, *Realismus: Theorie und Geschichte* (Munich: Fink, 1977). The interpretation (not reflection) of reality is inherent in art, which has developed for it indirect forms or counterprojections; it constitutes for the beholder the reference to life, even if he is seeking a "different" or "higher" reality. On the dialectic of the reference to reality in art, see Adorno, *Ästhetische Theorie*, passim, as well as the critique of Otto K. Werckmeister, *Ende der Ästhetik* (Frankfurt: Fischer, 1971), 7ff.

49. The problem of the reference to reality in modern art inevitably leads into—and ends up being replaced by—the problem of the modern conception of reality. Reality can be experienced as "abstract," as "partial," in excerpts or in fragments. The discussion of whether and how art takes a position on the reality of the modern consciousness is by no means closed, and in many instances has not even begun, even though since the tour de force of pop art the problem has become unavoidable. Analyses of the problem as such are therefore more common than demonstrations of how the problem is actually worked out in specific works or artists. Cf. Arnold Gehlen, *Zeit-Bilder: Zur Soziologie und Ästhetik der modernen Malerei* (Frankfurt: Athenaeum, 1960), and Henrich, "Kunst and Philosophie der Gegenwart," 11ff., as well as Adorno, *Ästhetische Theorie*, passim. "Reflectedness as the fundamental condition of contemporary consciousness" is assumed by art and leads to reflection on its own media and on its strategies of articulation or rejection of reality (Henrich, 14–15). "The abstract conditions of modern life are by themselves incapable of establishing in the work of art a general consciousness appropriate to these conditions." Art "has become partial, even with respect to content." Representation can be partial and yet "precisely in this quality associate itself with openness, reflexivity, and the historical formation" of the artist.

50. Max Beckmann, "On My Painting" (New York: Buchholz Gallery, 1941), 4; republished as "Über meine

Malerei" in *Sichtbares und Unsichtbares*, ed. Peter Beck-mann (Stuttgart: Belser, 1965), 20ff.: "To make the invisible visible through reality. . . . It is, in fact, reality which forms the mystery of our existence." The autonomy of this conception of reality is all too clear. Klee was cited by Werner Hofmann, *Zeitschrift für Kunstgeschichte* 18 (1955):136. Cf. also Antoni Tàpies, *Die Praxis der Kunst* (St. Gall, 1976), 58: "Just when certain people thought us furthest removed from authentic reality, we were in fact closest to it." In all these cases arises the problem of the distinction between the high claims and the achieved form of the interpretation (or conception) of reality.

51. Susan Sontag, *On Photography* (New York: Farrar, Straus and Giroux, 1977), 144 and passim. See also Gisèle Freund, *Photographie et société* (Paris: Éditions du Seuil, 1974), translated as *Photography and Society* (Boston: D. R. Godine, 1974); Beaumont Newhall, *Photography: Essays and Images* (New York: Museum of Modern Art, 1980); Erika Billeter, *Malerei und Photographie im Dialog von 1840 bis heute* (Bern: Benteli, 1977); and J. Adolf Schmoll gen. Eisenwerth, *Vom Sinn der Photographie* (Munich: Prestel, 1980).

52. Karin Sagner, *Claude Monet: "Nymphéas." Eine Annäherung;* dissertation (Munich, 1982), esp. 73ff.

53. The notion of "paradigm" is understood here in the sense of Thomas S. Kuhn, *The Structure of Scientific Revolutions* (Chicago: University of Chicago Press, 1962, 1970), passim. Cf. Thomas Zaunschirm in *Problemi di metodo*, 79ff.

54. Svetlana Alpers, "Is Art History?" *Daedalus* 106 (1977):1ff.

55. Wölfflin, *Principles*, 230.

56. On the concept of style, see Meyer Schapiro, "Style," *Anthropology Today*, ed. A. L. Kroeber (Chicago: University of Chicago Press, 1953), 287ff.: Jan Białostocki, *Stil und Ikonographie* (Dresden: VEB Verlag, 1966; Cologne: Du-Mont, 1981), esp. "Das Modusproblem in den Bildenden Künsten," 9ff. Millard Meiss, in *Painting in Florence and Siena after the Black Death* (Princeton, N.J.: Princeton University Press, 1951), presented style as an expression of social and cultural functions. Kurt Bauch responded to the threat of its dissolution through the professionalization of

scholarship with the concept of "iconographic style," in which particular functions are expressed. See also Belting, "Stilzwang und Stilwahl in einem byzantinischen Evangeliar in Cambridge," *Zeitschrift für Kunstgeschichte* 38 (1975):215ff.; and in *La Civiltà bizantina dal XII al XV secolo*, Università degli studi di Bari, Centro di studi bizantini, 3 (Rome: L'Erma di Bretschneider, 1982), 294ff. For an attempt at an analysis of function and the aesthetics of function, see Belting, *Das Bild und sein Publikum im Mittelalter* (Berlin: Mann, 1981). A volume edited by J. Adolf Schmoll gen. Eisenwerth and Helmut Koopman, *Beiträge zur Theorie der Künste im 19. Jh.* (Frankfurt: Klostermann, 1971, 1972), offers a good overview of the problem of style.

57. These statements must of course be modified with regard to modern art, in the sense that modern art has modified the character of a work of art and the reflection of art upon art. The work can be replaced here by a rite or a pose claiming for itself the work's earlier reference to the world, a specifically artistic reference to the world operating through or against aesthetic experience. (Cf. Allan Kaprow, *Assemblage, Environments and Happenings* (New York: Abrams, 1968); Udo Kultermann, *Leben und Kunst: zur Funktion der Intermedia* (Tübingen: Wasmuth, 1970); Wolf Vostell, *Happening und Leben* (Neuwied: H. Luchterhand, 1970); Jürgen Schilling, *Aktionskunst: Identität von Kunst und Leben* (Lucerne, 1978). On the other hand, the reflection of art upon art which is so common today has become the actual theme of art to such an extent that it takes on the aspect of a content. To the extent that art takes a position on itself and places itself in question, it explores a problem which does not arise out of itself but rather is brought to it from its environment (cf. also below, pp. 47–48). The history of a purely art-immanent development no longer accounts for this new situation.

58. Baxandall, *Painting and Experience in Fifteenth-Century Italy: A Primer in the Social History of Pictorial Style* (Oxford: Oxford University Press, 1972); Alpers, *The Art of Describing* (Chicago: Chicago University Press, 1983).

59. Michael Fried, *Absorption and Theatricality: Painting and Beholder in the Age of Diderot* (Berkeley and Los Angeles: University of California Press, 1980); Wolfgang Kemp, *Der Anteil des Betrachters: Rezeptionsästhetische Studien zur*

Malerei des 19. Jahrhunderts (Munich: Mäander, 1983); Norman Bryson, *Word and Image: French Painting of the Ancien Régime* (Cambridge: Cambridge University Press, 1981).

60. See my "La fin d'une tradition?" *Revue de l'art* 69 (1985):4ff.

61. I mention only the works of T. J. Clark on nineteenth-century French painting, and Martin Warnke, *Der Hofkünstler* (Cologne: DuMont, 1985).

62. Jauss, *Literaturgeschichte als Provokation*, 168ff. and 171ff.

63. Ibid., 170.

64. Alpers, "Is Art History?" passim. Cf. the series Art in Context edited by Hugh Honour, including Robert Herbert, *David, Voltaire, Brutus and the French Revolution* (New York: Viking, 1973), and Theodore Reff, *Manet, Olympia* (New York: Viking, 1977). Cf. also the works on modernism listed in note 57 above.

65. Books on the theory of signs are legion. See, for example, Umberto Eco, *A Theory of Semiotics* (Bloomington: Indiana University Press, 1976), and the schematic (but for that very reason revelatory of the limits and possibilities of "classical" semiotics) handbook of G. Kerner and R. Duroy, *Bildsprache 1 und 2* (Munich, 1977 and 1981).

66. This is meant in the sense of the study of linguistics in the tradition of Ferdinand de Saussure. See Belting, "Langage et réalité dans la peinture monumentale publique en Italie au '300," Acts of International Colloquium: Artistes, artisans et production artistique au Moyen Âge, (Université de Haute Bretagne-Rennes II, 1983); or "The New Role of Narrative in Public Painting of the Trecento: Historia and Allegory," in *Studies in the History of Art*, vol. 16 (Washington: National Gallery of Art, 1986). Cf. also James S. Ackerman, "On Rereading 'Style'" (by Meyer Schapiro; see note 56 above), *Social Research* 45 (1978):153ff. and 159 (a syntax of "established relationships" and options for several genres is called for). On the subject of a general theory of symbols, in which this conception of language has its place, see the attempts of Nelson Goodman, *Languages of Art* (Indianapolis: Hackett, 1976).

Further positions on this topic: Mohammed Rassem and Hans Sedlmayr, *Über Sprache und Kunst* (Mittenwald: Mäander, 1978); André Chastel and Georg Kauffmann in

Problemi di metodo, 105ff. and 251ff.; and Wladimir Weidlé, *Gestalt und Sprache des Kunstwerks* (Mittenwald: Mäander, 1981).

67. Sontag, *On Photography.* See esp. the chapter "The Image-World" (153ff.): "The new age of unbelief strengthened the allegiance to images." "A society becomes 'modern' when one of its chief activities is producing and consuming images" (153). "It is our inclination to attribute to real things the qualities of an image" (158). "The notions of image and reality are complementary" and subject to common transformations, such that the image is today often preferred over an incomprehensible reality (160). "Photograph collections can be used to make a substitute world" (162). "One can't possess reality, one can possess (and be possessed by) images" (163). Thus Sontag places the "real world" and the "image-world" (168) in a complex relationship of, so to speak, reciprocal use.

68. According to Arnold Gehlen (see note 49 above), who also speaks of the astonishing "inertia of the whole," the "power of endurance of style" in the context of public interest and market mechanisms: "General interest may also be directed at the already extinct; this is one of the differences between nature and culture. Semblance of death is a biological category, semblance of life cultural" (43).

69. One could proceed from a Hegelian position and then extend it in an anthropological sense; in attempting something like this Adorno offered arguments which are by no means committed to Hegel's standpoint. Special studies in this general realm of problems are already numerous: see Francis Haskell, *Patrons and Painters: Art and Society in Baroque Italy* (London: Chatto and Windus, 1962); Frederick Antal, *Florentine Painting and Its Social Background* (London: Kegan Paul, 1947); or the works of Michael Baxandall. See also the approaches to modern art cited in note 49 above.

70. Rosenberg, *The De-Definition of Art,* 209.

71. Cited in Gehlen, *Zeit-Bilder,* 41.

72. Thus formulated by Laszlo Glozer in the catalog *Westkunst* (Cologne: DuMont, 1981).

73. Mention, however, must be made of the contact with Adolf von Hildebrand, whose book *The Problem of Form,* in Wölfflin's words, "fell like a refreshing shower on parched

earth." It supposedly demonstrated that under historical modes of seeing "every standard of judgment of art, as such, is then lost," and that "the artistic content, which follows its own inner laws, unaffected by all temporal changes, is ignored" (*Classic Art*, xi). (See on this topic Lurz, *Wölfflin*, 156ff.) On the consonances between art history and the experience of art, see above, pp. 13–15 and below, 36–39.

74. Henry Thode, *Böcklin und Thoma* (Heidelberg, 1905) and *Kunst und Sittlichkeit* (Heidelberg, 1906); for a response see Max Liebermann, "Der Fall Thode," *Frankfurter Zeitung*, 1905. See above all Sedlmayr, *Verlust der Mitte* (Salzburg: Mueller, 1948); translated as *Art in Crisis: The Lost Center* (Chicago: Regnery, 1958). Ever since Spengler various suggestions of decadence, rupture, or loss have been in circulation, for instance in the 1920s from Jose Ortega y Gasset, *The Dehumanization of Art* (Princeton, N.J.: Princeton University Press, 1948; originally published in Madrid, 1925). See also Huntington Hartford, *Art or Anarchy? How the Extremists and Exploiters Have Reduced the Fine Arts to Chaos and Commercialism* (Garden City, New York: Doubleday, 1964).

75. For example Herbert Read: among his many works *Icon and Idea: The Function of Art in the Development of Human Consciousness* (London: Faber and Faber, 1955) stands out as an attempt at an integration of modernism within the universal history of art.

76. Rosenberg, *The Tradition of the New* (New York: Horizon Press, 1959). Books on tradition *in* modernism are not so rare as it seems at first glance, yet they have not established any coherent patterns of research and method: cf. Léonce Rosenberg, *Cubisme et tradition* (Paris, 1920); James T. Soby, *Modern Art and the New Past* (Norman: University of Oklahoma, 1957); Leo Steinberg, *Other Criteria: Confrontations with Twentieth-Century Art* (New York: Oxford University Press, 1972).

77. Julius Meier-Graefe, *Entwicklungsgeschichte der modernen Kunst* (Munich, 1914^2). Translated as *Modern Art* (London, New York, 1908). Cf. also the new edition (Munich, 1986) with preface by Belting.

78. Werner Weisbach, *Impressionismus* (cf. note 28 above.)

79. Max Dvořák, *Idealismus und Naturalismus in der gotischen Skulptur und Malerei* (Munich, 1918). Translated as *Idealism and Naturalism in Gothic Art* (South Bend: Notre Dame University Press, 1967).

80. Hans Tietze, *Die Methode der Kunstgeschichte* (Leipzig, 1913), 148ff. and 160–61.

81. Meyer Schapiro, "Recent Abstract Painting" (1957), in Schapiro, *Modern Art: Nineteenth and Twentieth Centuries* (New York: Braziller, 1978), 213ff.

82. Werner Hofmann, *Grundlagen der modernen Kunst* (Stuttgart: Kröner, 1966), especially 11ff., 34ff., 451ff., and 463ff.

83. Hofmann, "Es gibt keine Kunst, sondern nur Künste," in Hofmann, *Gegenstimmen: Aufsätze zur Kunst des 20. Jahrhunderts* (Frankfurt: Suhrkamp, 1979), 317ff.

84. Ibid., 319ff.

85. Cf. note 49 above.

86. See Belting, *Bild und Publikum.*

87. See Martin Warnke, *Der Hofkünstler* (note 61 above).

88. For this and other aspects, see Belting, "Das Werk im Kontext," in Belting et al., *Kunstgeschichte: Eine Einführung* (Berlin: Reimer, 1986), 186ff.

89. Suzi Gablik, *Progress in Art* (London: Thames and Hudson, 1976).

90. See note 75 above.

91. Fischer, *L'histoire de l'art est terminée,* passim.

92. Ibid., 37.

93. Ibid., 39. Cf. also note 49 above.

94. See, for example, Evelyn Weiss, "Kunst in Kunst—das Zitat in der Pop Art," *Aachener Kunstblätter* 40 (1971); the exhibition catalog *d'après* (Lugano, 1971); Jean Lipman and Richard Marshall, *Art about Art* (New York: Dutton, 1978); *Nachbilder—Vom Nutzen des Zitierens für die Kunst* (exhibition catalog, Hannover, 1979); Eduard Beaucamp, "Die Zukunft liegt in der Vergangenheit, *Frankfurter Allgemeine Zeitung,* 14 June 1980, supplement; Hans Belting, "Larry Rivers und die Historie in der modernen Kunst," *Art International* 25 (1982):72ff. See in addition the catalog *Mona Lisa im 20. Jh.* (Duisburg, 1978) and M. R. Storey, *Mona Lisas* (New York: Abrams, 1980); Horst Janssen, *Die Kopie* (Hamburg: Christians, 1977).

95. Rosenberg, *The De-Definition of Art,* 212ff. and 223ff.

96. Ibid., 218ff.

97. Rosenberg, *The Anxious Object*, 25ff. ("Past and Possibility").

98. Ibid., 28–29, 30–31.

99. Alfred Barr, Jr., *Cubism and Abstract Art* (New York: Museum of Modern Art, 1936).

100. Rosenberg, *The Anxious Object*, 33.

101. Granted, Rosenberg's argument here is directed not at Picasso but rather at the contemporary art scene, where it works better.

102. Fernand Léger, *Fonctions de la peinture*, ed. Roger Garaudy (Paris: Denoël, 1965), 30ff. For literary phenomena, cf. Jochen Hörisch and Hubert Winkels, eds., *Das schnelle Altern der neuesten Literatur* (Düsseldorf: Claassen, 1985), 7ff.

103. Roland Barthes, *La chambre claire* (Paris: Cahiers du cinéma, 1980), 182.

104. Jürgen Habermas, "Die Moderne—ein unvollendetes Projekt," address at the acceptance of the T. W. Adorno prize of the city of Frankfurt, September, 1980 (cf. *Frankfurter Allgemeine Zeitung* of 19 September 1980, 47–48).

105. Jasper Johns in an interview in *Art News* 72 (1973):21, formulated the relationship between old and new art polemically: "I think art criticizes art. . . . It seems to me old art offers just as good a criticism of new art as new art offers old."

106. Aldo Rossi, foreword to the catalog *Illuminism and Architecture in Eighteenth-Century Venice* (Venice, 1969); Massimo Scolari in Ezio Bonfanti et al., *Architettura razionale* (Milan: Angeli, 1973); exhibition catalog *Rational Architecture* (with contributions by Leon Krier and others) (London, 1975); Robert L. Delevoy, "Towards an Architecture," and Leon Krier, "The Reconstruction of the City," in *Rational Architecture: The Reconstruction of the European City* (Brussels: Archives d'architecture moderne, 1978), 14ff., 38ff.; Henryk Skolimovski, "Rationality in Architecture and the Design Process," as well as Charles Jencks, "Irrational Rationalism," in *The Rationalists: Theory and Design in the Modern Movement*, ed. Dennis Sharp (London: Architectural Press, 1978), 160ff., 208ff.; Leon Krier, *Contre-projets* (Brussels: Archives d'architecture moderne, 1980).

107. Krier, "The Reconstruction of the City." The "re-creation of the public realm" is linked to the reproach of the "cultural machine" for concealing "social emptiness behind an ephemeral and prestigious formalism."

108. Cf. note 106 above, as well as Bernard Huet, "Small Manifesto," in *Rational Architecture,* with the lapidary pronouncement that architecture "began" in the fifteenth century with the bourgeoisie.

109. Thus B. Maguire, "Vom Wert der Tradition," in Gerald R. Blomeyer and Barbara Tietze, eds., *In Opposition zur Moderne: Aktuelle Positionen in der Architektur* (Braunschweig: Vieweg, 1980), 80ff. and esp. 85. See also the polemic work of Eberhard Schulz, *Das kurze Leben der modernen Architektur: Betrachtungen über die Spätzeit des Bauhauses* (Stuttgart: dva, 1977) and Brent C. Brolin, *Architecture in Context: Fitting New Buildings with Old* (New York: Van Nostrand Reinhold, 1980).

110. Lecture at the University of Munich on 10 February 1983. Cf. Stirling's address upon his acceptance of the Gold Medal in architecture (*Architectural Design* 7/8 [1980]:6ff.). See also Stirling, *Buildings and Projects, 1950–1974* (New York: Oxford University Press, 1975), esp. 12 on the "style" of a building. In addition, see the positions in the works mentioned in the previous note.

111. Hanno-Walter Kruft, *Geschichte der Architekturtheorie von der Antike bis zur Gegenwart* (Munich: C. H. Beck, 1985), 504ff., with useful survey.

112. The confusion of the object and purpose of an art-historical enterprise with the goal of reestablishing conservative standards of value is becoming unsettlingly common these days, for example in the appeal to the realism of early Beckmann against abstract art (*Max Beckmann: Die frühen Bilder* [Bielefeld: Kunsthalle, 1982]). This is not the same as in the art scene of the German Democratic Republic, where artists attempt neorealisms in Beckmann's sense in order to interpret their environment (see the exhibition catalog *Zeitgeist,* Hamburg, 1982). Antimodernism becomes virulent only where arguments against classical modernism are sought in important currents of the twentieth century. New titles reveal the eagerness of the champions of modernism and their adversaries to apply clear labels: cf. Suzi Gablik, *Has Modernism Failed?* (London:

Thames and Hudson, 1984); Rosalind E. Krauss, *The Originality of the Avant-Garde and Other Modernist Myths* (Cambridge, Mass.: MIT Press, 1985); Hal Foster, ed., *Post-Modern Culture* (London: Pluto Press, 1985).
113. Cf. note 112 above.

Two: Vasari and His Legacy

1. Theodor W. Adorno, *Ästhetische Theorie*, Gesammelte Schriften, vol. 7 (Frankfurt: Suhrkamp, 1970), 533; translated as *Aesthetic Theory* (London, Boston: Routledge and Kegan Paul, 1984), 492: "Just as, according to Valéry, the best features of the new correspond to an old need, so authentic modern works are criticisms of past ones."
2. Johann Joachim Winckelmann, *Geschichte der Kunst des Altertums* (Dresden, 1764). Translated by G. Henry Lodge as *History of Ancient Art*, various editions; cited here after the edition of Ludwig Goldscheider (Vienna: Phaidon, 1934).
3. Johann Gottfried Herder, *Kritische Wälder* (1769). In *Sämmtliche Werke*, ed. Bernhard Suphan (Berlin: Weidmann, 1878), 3:419.
4. "Vasari und die Folgen: Die Geschichte der Kunst als Prozess?" in Karl-Georg Faber and Christian Meier, eds., *Theorie der Geschichte 2: Historische Prozesse* (Munich: Deutscher Taschenbuch Verlag, 1978), 98ff.
5. Adorno, *Ästhetische Theorie*, 262; *Aesthetic Theory*, 252.
6. George Kubler, *The Shape of Time: Remarks on the History of Things* (New Haven: Yale University Press, 1962).
7. Ernst H. Gombrich, "Norm and Form: The Stylistic Categories of Art History and Their Origins in Renaissance Ideals," in *Norm and Form: Studies in the Art of the Renaissance* (London: Phaidon, 1966, 1978), 81–82, 88.
8. Henri Focillon, *La Vie des formes* (Paris: P.U.F., 1939).
9. Heinrich Wölfflin, *Kunstgeschichtliche Grundbegriffe: Das Problem der Stilentwicklung in der neueren Kunst* (Munich, 1915), 244ff.; trans. M. D. Hottinger as *Principles of Art History: The Problem of the Development of Style in Later Art* (London: G. Bell, 1932; New York: Dover, 1950) (conclusion: "The outer and inner history of art," 226ff).
10. Wölfflin, *Principles of Art History*, 230.
11. Ibid., 227: "In its breadth, the whole process of the

transformation of the imagination has been reduced to five pairs of concepts. We can call them categories of beholding."

12. Gombrich, *Norm and Form*, 90ff.

13. Georg Friedrich Wilhelm Hegel, *Ästhetik*, ed. H. G. Hotho (Berlin, 1835, 1842, 1953), 2:244–45; trans. by T. M. Knox as *Aesthetics: Lectures on Fine Art* (Oxford: Oxford University Press, 1975), 2:614.

14. Giorgi Vasari, *Le vite de' più eccellenti pittori, scultori ed architettori italiani*, ed. Gaetano Milanesi (Florence, 1878–85); various English editions. Out of the vast literature on Vasari see especially, as well as the essays by Gombrich and Alpers cited in the following note: Wolfgang Kallab, *Vasaristudien*, ed. Julius von Schlosser (Vienna, 1908); Schlosser, *Die Kunstliteratur* (Vienna: Schroll, 1924), 251–304, or *La letteratura artistica*, ed. Otto Kurz (Florence: Nuova Italia, 1956), 289–346; *Studi Vasariani*, Atti del Congresso Internazionale del IV Centannaio della prima edizione delle Vite del Vasari (Florence, 1952); Jean Rouchette, *La Renaissance que nous a léguée Vasari* (Paris: Les Belles Lettres, 1959); Ralf Reith, *Wissenschaftliche Begriffssprache und Systematik bei Vasari: Der Begriff "arte" nach den theoretischen Teilen der "Lebensbeschreibungen"* (dissertation, Heidelberg, 1966); *Il Vasari storiografo e artista*, Atti del Congresso Internazionale nel IV Centennaio della morte (Florence, 1976).

15. Svetlana Leontief Alpers, "Ekphrasis and Aesthetic Attitude in Vasari's *Lives*," *Journal of the Warburg and Courtauld Institutes* 23 (1960):190ff.; cf. Gombrich, "Vasari's *Lives* and Cicero's *Brutus*," *Journal of the Warburg and Courtauld Institutes* 23 (1960):309ff., and Gombrich, "The Renaissance Conception of Artistic Progress and Its Consequences" (1952), in *Norm and Form*, 1–10, esp. 5ff. Cf. also Schlosser, *La letteratura*.

16. Vasari, *Le vite*, ed. Milanesi, 2:94 (introduction to part 2).

17. The model of the cycle is developed especially in the introduction to part 2 of the *Lives*. Cf. also Gombrich, "Artistic Progress."

18. Vasari, *Le vite*, 2:96.

19. Ibid., 1:232–33; 2:95, 97.

20. Ibid., 2:96. Cf. also Alpers, "Ekphrasis," passim.

21. Vasari, *Le vite*, 2:94.

22. Ibid., 2:96; 4:12–13.

23. Ibid., 2:102–3.

24. See Gombrich, "Artistic Progress," and Reith, *Wissenschaftliche Begriffssprache.*

25. Adorno, *Ästhetische Theorie,* 310–11; *Aesthetic Theory,* 299.

26. See Alpers, "Ekphrasis," 206ff., as well as Gombrich, "Artistic Progress," 6ff., and Gombrich, "The Leaven of Criticism in Renaissance Art," in *Art, Science, and History in the Renaissance,* ed. Charles S. Singleton (Baltimore: Johns Hopkins University Press, 1967), esp. 20ff.; reprinted in Gombrich, *The Heritage of Apelles: Studies in the Art of the Renaissance* (London: Phaidon, 1976), 111ff. On problem solving as a general model of artistic development, see Kubler, *Shape of Time,* 33ff.

27. Vasari, *Le vite,* 4:26. The statement refers specifically to Leonardo but may be taken as an expression of a general model of explanation.

28. Ibid., 2:107.

29. Ibid., 7:215.

30. Ibid., 4:584.

31. Ibid., 13.

32. Ibid.

33. Ibid., 10.

34. Alpers, "Ekphrasis," 206ff.

35. Leonardo da Vinci, *Treatise on Painting* (Cod. Urb. lat. 1270), ed. A. Philip McMahon (Princeton, N.J.: Princeton University Press, 1956), vol. 2, fol. 33v.

36. Lorenzo Ghiberti, *I commentarii,* ed. Julius von Schlosser (Berlin: J. Bard, 1912), vol. 1.

37. On Vasari's sources, see Kallab, *Vasaristudien.*

38. Ghiberti, *Commentarii,* 25. Cf. Gombrich, "Artistic Progress," 7, and "Leaven of Criticism," 20ff.

39. *Leon Battista Alberti's kleinere Schriften,* ed. Hubert Janitschek, Quellenschriften für Kunstgeschichte und Kunsttechnik des Mittelalters und der Renaissance XI (Vienna, 1877), 228–29.

40. Arnold Gehlen, *Zeit-Bilder: Zur Soziologie und Ästhetik der modernen Malerei* (Frankfurt: Athenaeum, 1960), 29. See also James S. Ackerman, "Ars sine scientia nihil est," *Art Bulletin* 31 (1949). On the idea of progress through problem solving in "ordinary science," see Thomas S.

Kuhn, *The Structure of Scientific Revolutions* (Chicago: University of Chicago Press, 1962).

41. Gehlen, *Zeit-Bilder*, 30.

42. On the emancipation of the artist from medieval constrictions, see Martin Wackernagel, *Der Lebensraum des Künstlers in der florentinischen Renaissance* (Leipzig: Seemann, 1938), and Rudolf Wittkower and Margot Wittkower, *Born under Saturn: The Character and Conduct of Artists* (London: Weidenfeld and Nicolson, 1963). On the medieval artist, see most recently John Harvey, *Mediaeval Craftsmen* (London: Batsford, 1975); on the mechanical and liberal arts see J. Seibert in the *Lexikon der christlichen Ikonographie* (Freiburg i. Br.: Herder, 1970), vol. 2, cols. 702ff.

43. Robert Oertel, "Wandmalerei und Zeichnung in Italien," *Mitteilungen des Kunsthistorischen Instituts in Florenz* 5 (1940):217ff., esp. 239ff., 255ff.

44. Ibid., 255ff.

45. On this relationship see above all Hans Baron, *The Crisis of the Early Italian Renaissance* (Princeton, N.J.: Princeton University Press, 1955).

46. Adorno, *Ästhetische Theorie*, 336–37; *Aesthetic Theory*, 322.

47. André Chastel, *Marcel Ficin et l'art* (Geneva: Droz, 1954), 129ff., as well as Raymond Klibansky, Erwin Panofsky, and Fritz Saxl, *Saturn and Melancholy: Studies in the History of Natural Philosophy, Religion, and Art* (London: Nelson, 1964), 241ff.

48. Vasari, *Le vite*, 4:315–16, 384–85 ("Egli, in somma, non visse da pittore, ma da principe").

49. On humanistic aesthetic doctrine and its antique roots, see Michael Baxandall, *Giotto and the Orators: Humanist Observers of Painting in Italy and the Discovery of Pictorial Composition 1350–1450* (Oxford: Oxford University Press, 1971).

50. In Dürer's drafts for the introduction to the treatise on proportion. Cited by Arthur Haseloff, "Begriff und Wesen der Renaissancekunst," *Mitteilungen des Kunsthistorischen Instituts in Florenz* 3 (1919):374.

51. On this topic see Gombrich, "Mannerism: The Historiographic Background," in *Norm and Form*. Vasari's efforts to prepare a future for the history of art, through

warnings against the blind imitation of Michelangelo and praise for Raphael's independence, are no substitute for the missing model of the continuation of art.

52. Gombrich, "Mannerism," 103. On the problem of the evaluation of mannerism, see also the contributions to the section "Recent Concepts of Mannerism," in *The Renaissance and Mannerism*, Studies in Western Art; Acts of the Twentieth International Congress of History of Art II (Princeton, 1963); and Wladyslaw Tatarkiewicz, "Wer waren die Theoretiker des Manierismus?" *Zeitschrift für Ästhetik und allgemeine Kunstwissenschaft* 12 (1967):90ff.

53. Nikolaus Pevsner, *Academies of Art Past and Present* (Cambridge: Cambridge University Press, 1940).

54. Licia Ragghianti Collobi, *Il libro de' Disegni del Vasari* (Florence: Vallecchi, 1974).

55. Erwin Panofsky, "The First Page of Giorgio Vasari's 'Libro': A Study on the Gothic Style in the Judgment of the Italian Renaissance," in *Meaning in the Visual Arts* (Garden City, N.Y.: Doubleday, 1955), 169ff.

56. Article 22 of the Statutes calls for a painted or relief frieze in the building of the Academy with portraits of all members and famous older masters since Cimabue; article 30 envisions an exhibition hall, article 31 a "libreria" for the inherited "disegni, modelli di statue, piante di edifizii, ingegni da fabbricare" as study material "pe i giovani per mantenimento di quest'arti."

57. See the works of Julius von Schlosser cited in note 14 above as well as Panofsky, *Idea* (Leipzig: Teubner, 1924; Berlin: Hessling, 1960), translated as *Idea* (Columbia, S.C.: University of South Carolina Press, 1968), and Denis Mahon, *Studies in Seicento Art and Theory* (London: Warburg Institute, 1947).

58. Cf. note 2 above. On Winckelmann, see the three volumes of Carl Justi, *Winckelmann und seine Zeitgenossen* (Leipzig, 1898), which remains the standard work.

59. Winckelmann, *Geschichte*, 295.

60. Ibid.

61. Ibid., 225.

62. Ibid., 207.

63. Ibid., 139.

64. Ibid., 321.

65. Ibid., 345.

66. Ibid., 364.

67. Ibid., 335.

68. Ibid., 295.

69. Ladendorf used this phrase with reference to the nineteenth century and the notion (inaugurated by Winckelmann) of the "beholding of form" as historically directed contemplation. Heinz Ladendorf, *Antikenstudium und Antikenkopie* (Berlin: Akademie-Verlag, 1953), 48.

70. Hermann Bauer, *Kunsthistorik: Eine kritische Einführung in das Studium der Kunstgeschichte* (Munich: Beck, 1976), 71.

71. Winckelmann, *Geschichte,* 179.

72. Ibid., 128.

73. Carl Friedrich von Rumohr, *Italienische Forschungen (1827–31),* ed. Julius von Schlosser (Frankfurt, 1920), esp. 179ff. One would not wish to reproach Vasari "for organizing his material not in a scholarly and critical manner but rather artistically and poetically. One may only reproach the compilers who plagiarized him, and the critics who contradicted him without amending him: the former for relying upon him as a source for such a vast range of topics, the latter for not having recognized that Vasari's errors . . . were not deliberate lies . . . but merely misunderstood historical truths. While the superficial critic is content to contest these errors, the true critic is inspired to search out their causes" (460–61, 482–83).

74. On the constant reevaluations of the Gothic through the ages, see Paul Frankl, *The Gothic: Literary Sources and Interpretations through Eight Centuries* (Princeton, N.J.: Princeton University Press, 1960).

75. Johann David Passavant, *Ansichten über die bildenden Künste und Darstellung derselben in Toscana* (Heidelberg and Speyer, 1820), 9. The formulation picks up the then well known half-verse from Schiller's "Resignation:" "Die Weltgeschichte ist das Weltgericht"; cf. Reinhart Koselleck in *Geschichtliche Grundbegriffe* 2 (Stuttgart: Klett, 1975), 667.

76. Passavant, *Ansichten,* 6.

77. Ibid., 18; cf. also 14ff.

78. Ibid., 19.

79. Ibid., 27. Although Vasari (*Le vite,* 2:106) hesitated on whether or not to include Donatello among the masters

of the third epoch, to which he did not actually belong chronologically, no single case could ever call in question the general validity of the schema.

80. Passavant, *Ansichten*, 27.

81. Ibid., 37–38.

82. Ibid., 38.

83. Ibid., 46.

84. Ibid., 46ff.

85. Ibid., 52–53.

86. René Wellek, "Zur methodischen Aporie einer Rezeptionsgeschichte," in *Geschichte—Ereignis und Erzählung*, Poetik und Hermeneutik 5, ed. Reinhart Koselleck and Wolf-Dieter Stempel (Munich: Fink, 1973), 517.

87. Cf. note 6 above.